TIGER STADIUM

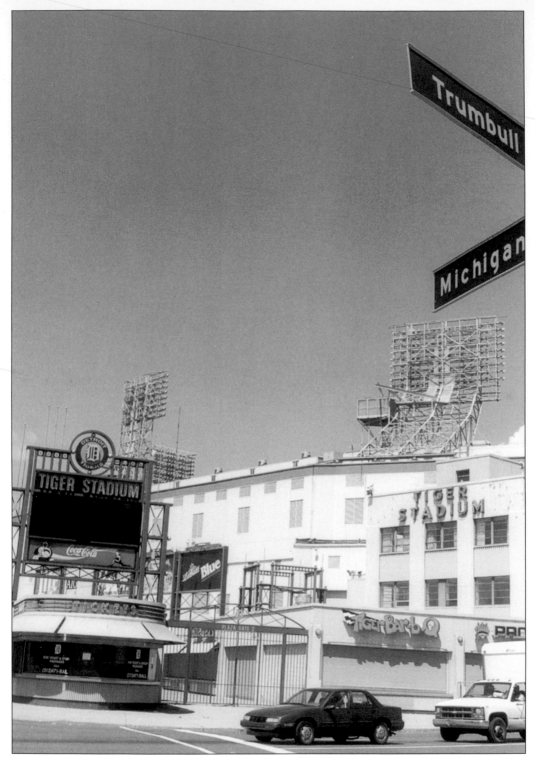

From April 28, 1896, to the last game on September 27, 1999, Michigan and Trumbull was the site of professional baseball in Detroit. (Photo by author.)

TIGER STADIUM

Irwin J. Cohen

ARCADIA
PUBLISHING

Published by Arcadia Publishing
Charleston SC, Chicago IL, Portsmouth NH, San Francisco CA

Printed in the United States of America

Library of Congress Catalog Card Number: 2003100023

For all general information contact Arcadia Publishing at:
Telephone 843-853-2070
Fax 843-853-0044
E-mail sales@arcadiapublishing.com
For customer service and orders:
Toll-Free 1-888-313-2665

Visit us on the Internet at www.arcadiapublishing.com

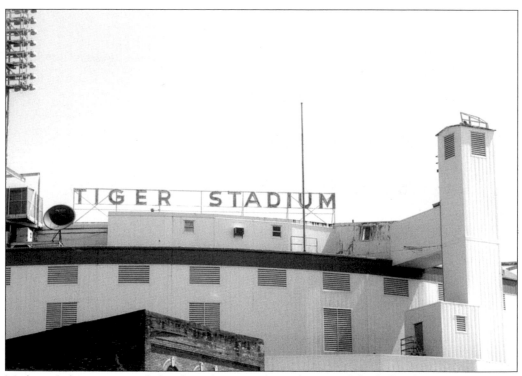

Media people experienced the slow elevator ride to the top of the ballpark, and then had to walk upward through a long, chute-like hallway before entering the rear of the press box behind the infield. (Photo by author.)

CONTENTS

ACKNOWLEDGMENTS

As an editor-publisher, writer, and photographer for the monthly national *Baseball Bulletin* (1975–1980), I made some long-lasting contacts with many individuals in the front office of the Detroit Tigers. Thee contacts ultimately led to a front office position with the Tigers and a 1984 World Series ring (see Introduction).

I cherished the time spent with the real baseball people—executives and other employees in the front office; the people in the broadcast booths, photographer hangars, press boxes, and concession stands; and the ushers, ticket-takers and those who hovered over the turnstiles. They shared their memories and photographs.

Time and some of the people at the old ballpark have passed on, but the photographs will serve as a vivid, permanent memory. The late Jim Campbell, former Tigers president and chief operating officer, and public relations chief Hall Middlesworth were kind enough to pass along some of their photographs.

Baseball historian Marc Okkonen, a talented graphic artist, stepped up to the plate and provided the best depictions of Bennett Park, Navin Field and Briggs Stadium. A special thank you to my closer, Loretta Crum, who scores with all my projects. And, as always, the courteous, knowledgeable staff of the Burton Historical Collection of the Detroit Public Library, under the direction of author-historian David Lee Poremba, was a vast reservoir of early Tigers' history.

Many of the photographs included here I took during my years as a fan, writer-photographer, and front office worker. Of all the books on Tiger Stadium through the years, I'm proud that this one will give the reader a fine picture of what the old ballpark at Michigan and Trumbull was like through its life.

The best way to memorialize Tiger Stadium, I feel, is to divide its history into five chronological sections: Bennett Park, Navin Field, Briggs Stadium, Tiger Stadium, and the historic last day.

INTRODUCTION

Michigan and Trumbull.

That was the address for pro baseball in Detroit for 104 seasons. From 1896 when Bennett Park opened, until the last game at Tiger Stadium in 1999, Michigan and Trumbull was the most famous street corner in Michigan.

Generations came, watched, bonded, and remembered the great players and the great moments. For half a century I experienced the old ballpark. From 1949 through 1999, I saw the blazing fastballs of Bob Feller, Herb Score, and Nolan Ryan. I witnessed the guile of Whitey Ford, Eddie Lopat, and Satchell Paige baffle the home team. I watched Joe DiMaggio's last at-bat in Detroit in a night game in August of '51 (DiMag popped up to shortstop Neil Berry). I arrived early to catch Mickey Mantle, Roger Maris, and Ted Williams take batting practice and rattle those wooden green seats with their shots.

I often stared at the leftfield stands and recalled coming to my first game. My favorite Tiger, outfielder Hoot Evers, doubled off the fence at the 365-mark in front of my grandstand seat, making my day. It still replays in my mind several times a week.

While Detroit was celebrating its 250th birthday, Evers was having the worst season of his career. My hero batted .224 in 1951, 99 points under his 1950 average of .323. After Evers was traded to Boston in 1952, my mother gave me permission to take the bus to Briggs Stadium when the Red Sox and Evers came to town the following year. I hung around the visitors' clubhouse door after the game, hoping to catch a glimpse of my favorite player. Evers was one of the first players to leave and stood near the door, waiting for a teammate.

I summoned all the courage I had, walked over, and asked for an autograph.

"Beat it, kid," my favorite player muttered.

"But you're my favorite player," I heard myself say.

"That's what they all say," Evers said. "Now beat it."

I beat it to the other side of the wall and continued to watch my favorite player until he left with some teammates.

Fast forward to February 1973.

Detroit had a weekly sports call-in show on Monday nights. Once, after the program ended, I collected enough nerve to call the host and inform him of an error he made on the air regarding Tiger Stadium history.

The host was nice and put me at ease.

"By the way, who's your guest on the program next Monday?" I asked.

"Hoot Evers," he replied. "He's the director of the minor leagues for the Tigers and not many people remember that he played for the Tigers."

"Evers!" I exclaimed. "He was my all-time favorite player!"

"Why don't you come down to the station next Monday and introduce him on the program?" he suggested. "It would be a nice touch to have a fan introduce his hero."

I arrived early the following Monday and studied the introduction while I waited. It was the first piece of writing I had done since those forced school reports over a decade earlier.

A tall man wearing a rumpled, gray, Peter Falk-as-Columbo style coat and a well-worn gray hat arrived.

"Hi Hoot," the host said as he extended his hand. The host introduced me and told Evers about my role. We shook hands and were ushered into the studio. Soon the light and I went on.

The program went well and quickly. Evers' car was back at Tiger Stadium, and he accepted my offer to drop him off. We chatted about the 1950 season while rolling down Fort Street to Trumbull. Near the stadium I felt confident enough to mention our last meeting in 1954.

"I brushed everybody off," Evers chuckled and wished me well as he exited my car. It was back to the real world the next day as I headed to my civil service job in Detroit's City Hall. Now, though, I was thinking about the Evers introduction and ways to extend my less than fifteen minutes of fame.

I spent numerous lunch hours at the downtown library, perusing the sports sections of out-of-town newspapers, and I started to collect baseball related information. After a bit of typing and tinkering, I decided to send some of it off to Joe Falls, then with the *Detroit Free Press*.

Just before sealing the envelope, I crossed out my name and substituted "Mr. Baseball." After all, that carried much more weight. Falls, who had no idea from whence they came, began to use some of my pieces in his Sunday column and often quoted Mr. Baseball.

It was time to introduce myself. Falls invited me to his *Free Press* office and took me to the photographer without any further explanation. The next day, the last of February 1973, I was startled to see my picture, along with some of my contributions, in Falls' column.

I kept up the Mr. Baseball relationship with Falls and tried my hand at writing for national baseball related publications, with some luck. A decade of writing fostered a relationship with many in the Tigers' organization, including Hoot Evers. When a spot on the front office roster opened in late 1983, I became part of the history of the Detroit Tigers.

My office was on the second floor of the three-story Tiger Stadium front office building on Trumbull. I was given a big, old, brown desk with hard-to-open drawers. A heavy, semicircular armchair also was brought out of storage. It reeked of history.

It had belonged to former Tigers owner Frank Navin.

I thought of the many players who had signed their contracts in front of Navin on top of the desk. I never thought the Tigers would top all clubs in my first season with the team and that I would be awarded a World Series ring.

The biggest thrill, though, took place several weeks after the 1984 World Series.

The ticket department was being computerized, and every seat and bleacher space in the ballpark had to be verified according to the existing schematics. I was tagged to match all the seating via the diagrams. It meant visiting every seat in every section.

So, I'm the answer to the trivia question "Who counted every seat and bleacher space in Tiger Stadium?"

All because of Hoot Evers and a chance phone call

ONE

Bennett Park
1896–1911

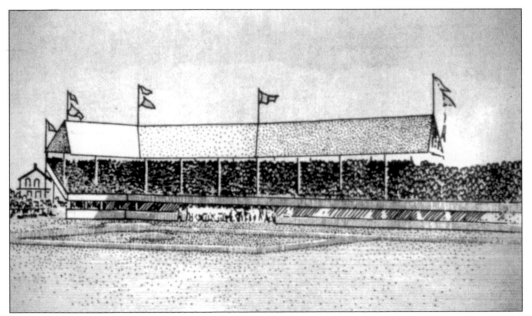

Bennett Park, named after former catcher Charlie Bennett, who lost part of his legs in a train accident, opened on April 28, 1896. Detroit, a member of the Western League at the time, defeated Columbus 17-2 in the first professional game at Michigan and Trumbull. Team captain George Stallings hit the first home run. (Courtesy Burton Historical Collection of the Detroit Public Library.)

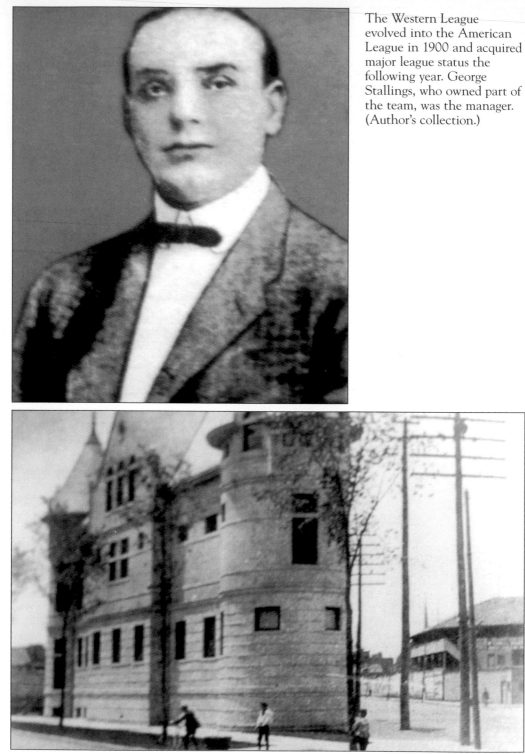

The Western League evolved into the American League in 1900 and acquired major league status the following year. George Stallings, who owned part of the team, was the manager. (Author's collection.)

Rowdy fans were hauled off to the Trumbull police station, located near Bennett Park's main entrance. (Burton Historical Collection of the Detroit Public Library.)

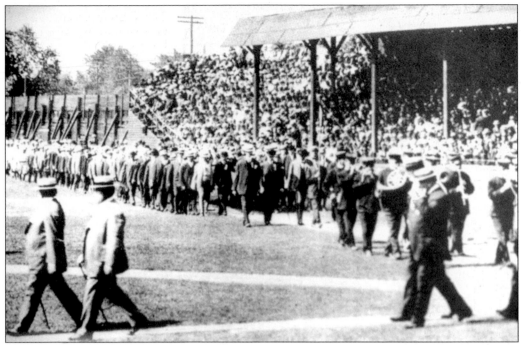
Opening Day was a time for a ceremonial march past first base to home plate and up the third base line. (Courtesy Burton Historical Collection of the Detroit Public Library.)

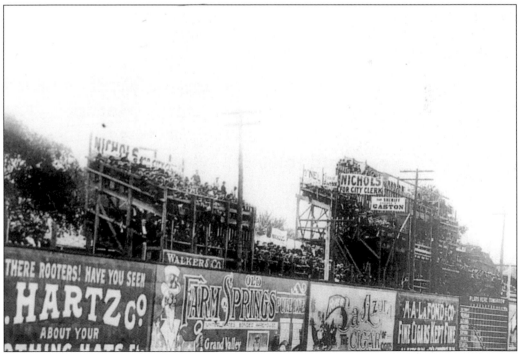
Homeowners behind the left field wall added bleachers above their houses, raking in extra income at the Tigers' expense. (Courtesy Burton Historical Collection of the Detroit Public Library.)

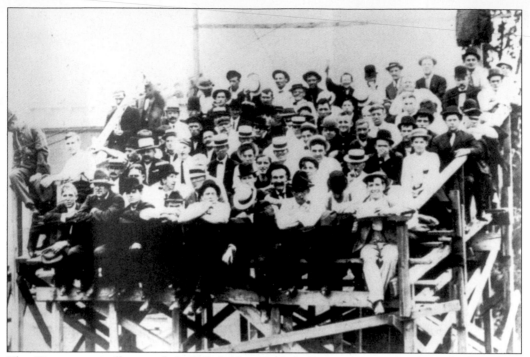

The Tigers eventually raised the left field wall, providing more revenue through the sale of advertising space and blocking out the view of those in temporary bleachers on top of houses. (Courtesy Burton Historical Collection of the Detroit Public Library.)

COBB EXPECTED TO MAKE HIS LOCAL DEBUT TODAY

Georgian in Town Anxious to Start Work in Tiger Outfield.

TYRUS COBB.

Detroit probably will present a new face in the outfield this afternoon. Tyrus Cobb, the speedy youngster from the Augusta South Atlantic league club, having arrived in the city last evening, ready to go in as soon as called on. Cooley is out of the game for a time, and Bob Lowe is willing to surrender an outfield job to anybody that wishes it. Accordingly, it is likely that Tyrus will get his chance in a hurry. The Georgian was a little fatigued last evening, having been on the way since Saturday. Ordinarily the trip is one of about thirty hours, but missed connections at Atlanta and Cincinnati set back the tourist. He thought, however, that one night's rest would put him on his feet.

Cobb played on Thursday and Friday with Augusta, and in those two games hit a batting clip that regained for him the leadership of his league, which he had lost for a time to Sentell, of the Macon club. He quit the South Atlantic with a hitting batting average of .328. He won't pile up anything like that in this league, and he

with a .275 mark he will be satisfying everybody.

The local players had opportunity to watch Cobb last spring, when training in Augusta, and were impressed with his speed. Bill Byron, who umpired in the South Atlantic, says the youngster is one of the fastest men

Newly arrived Ty Cobb would make his major league debut on August 30, 1905, as the newspaper article that day tells. Cobb doubled in a run in his first at-bat as a Tiger. (Courtesy Burton Historical Collection of the Detroit Public Library.)

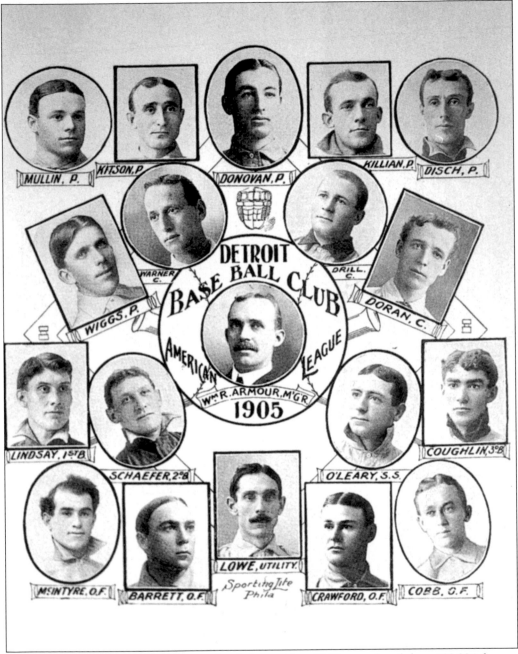

The 1905 Tigers ended the season in third place with a 79-74 record and drew 193,384 fans to Bennett Park. It was their best winning percentage since their charter 1901 beginning in the American League. (Author's collection.)

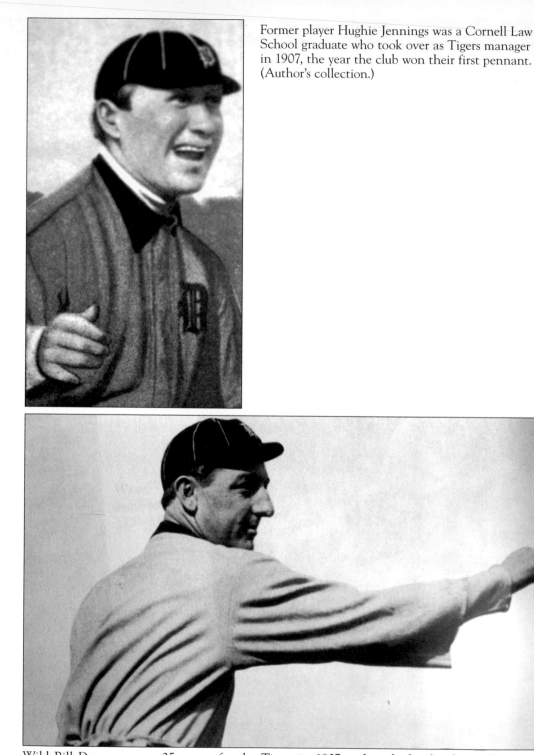

Former player Hughie Jennings was a Cornell Law School graduate who took over as Tigers manager in 1907, the year the club won their first pennant. (Author's collection.)

Wild Bill Donovan won 25 games for the Tigers in 1907 and pitched a four-hour, 17-inning tie. The Tigers lost the World Series to the Cubs despite Donovan's low 1.71 ERA in 21 Series innings. (Courtesy Burton Historical Collection of the Detroit Public Library.)

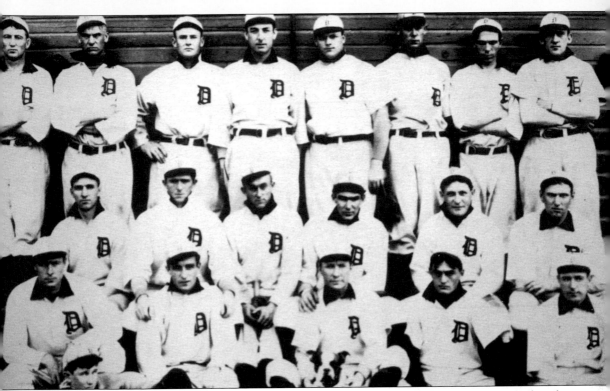

The 1907 Tigers won 92 games and lost 58. The Tigers won one World Series game and tied another. The team members, pictured from left to right, are: (front row) Ed Siever, Jimmy Archer, Hughie Jennings, Charley Schmidt, and Charley O'Leary; (middle row) Davey Jones, Red Downs, Ty Cobb, Bill Coughlin, Germany Schaefer, and Bumpus Jones; (back row) John Eubank, Claude Rossman, Sam Crawford, Bill Donovan, George Mullin, Ed Willett, Fred Payne, and Ed Killian.

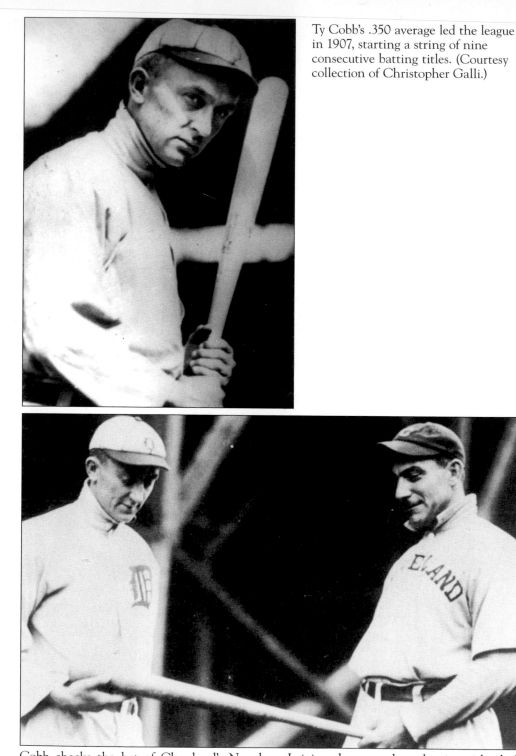

Ty Cobb's .350 average led the league in 1907, starting a string of nine consecutive batting titles. (Courtesy collection of Christopher Galli.)

Cobb checks the bat of Cleveland's Napolean Lajoie, who won three batting titles before Cobb made his debut. Lajoie was one of baseball's most popular personalities, while Cobb was generally disliked. (Courtesy Burton Historical Collection of the Detroit Public Library.)

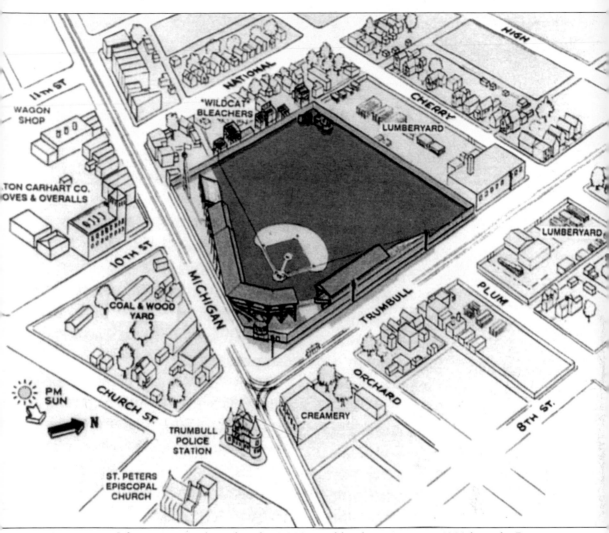

Expansion of the main grandstand and a 2,000-seat bleacher section in 1908 brought Bennett Park's seating capacity to over 10,000. A new attendance record was set on opening day as 14,051 paid their way into the ballpark to sit in its freshly painted yellow seats. Thousands, though, had to stand along the foul lines and in the outfield. (Courtesy Marc Okkonen.)

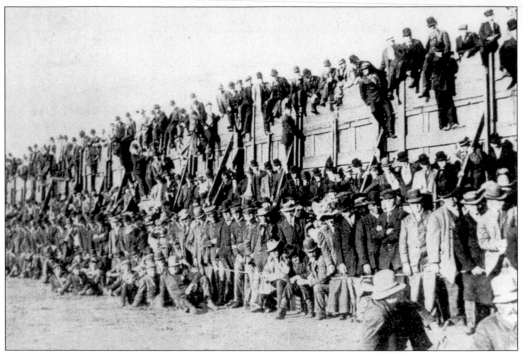

It was 371 feet down the tight field foul line to the outfield wall at Bennett Park. However, when the Tigers sold more tickets than seats in 1908, part of right center field was roped off to accommodate the fans. Those who tired of standing climbed to the top of the wall to sit. (Courtesy Burton Historical Collection of the Detroit Public Library.)

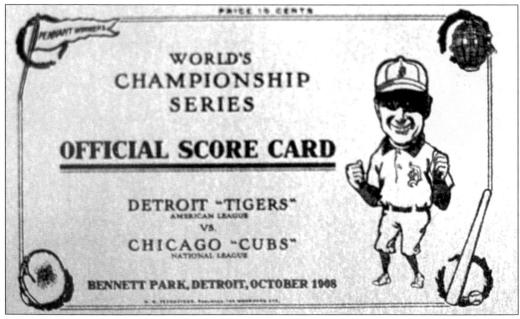

The Tigers and Cubs met again in the 1908 World Series. The Tigers lost the Series again, four games to one. The last game drew only 6,210 to Bennett Park, the smallest crowd ever in World Series history. (Author's collection.)

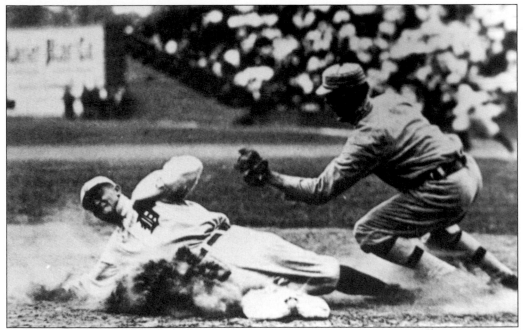

In 1909, Ty Cobb hit .377, belted nine home runs, and swiped 76 bases, all league-leading marks. The Tigers had their highest attendance to date as 490,490 fans paid their way into Bennett Park. (Courtesy Burton Historical Collection of the Detroit Public Library.)

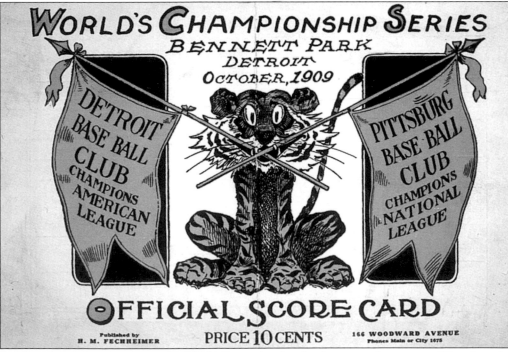

Cobb and the Tigers were in the World Series for the third time in three years. They lost the Series again, this time to Pittsburgh in seven games. The third game drew a record Bennett Park crowd of 18,277. (Author's collection.)

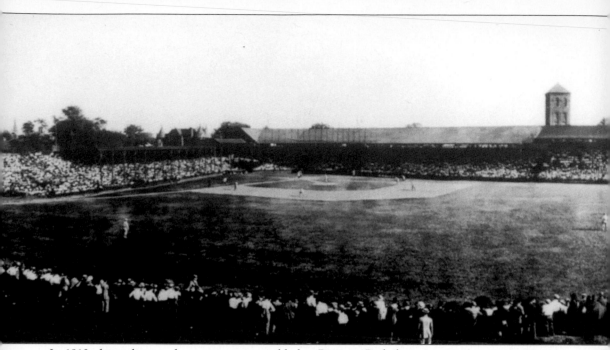

In 1910, three thousand more seats were added to Bennett Park, bringing its capacity to 13,000. The Tigers hoped to draw more than half a million fans, but even though Ty Cobb led the league in hitting with a .385 batting average, the team slipped to third place and attendance plummeted to 391,288. Attendance and the team improved in 1911 as Cobb had an explosive season, batting .420 and stealing 83 bases. After the season, owner Frank Navin built a new ballpark instead of adding on to Bennett Park.

TWO

Navin Field
1912–1937

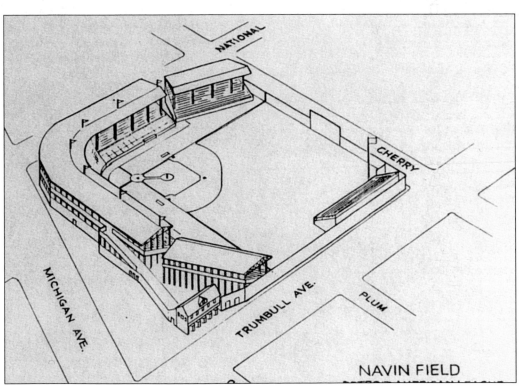

The newly reconfigured, 23,000-seat concrete ballpark, designed by Osborn Engineering of Cleveland, was named after Tigers owner Frank Navin. The infield was moved away from Michigan and Trumbull to where left field had been, and the old infield became part of right field. Navin Field featured a green outfield wall without advertising panels, providing a good background for hitters. (Courtesy Marc Okkonen.)

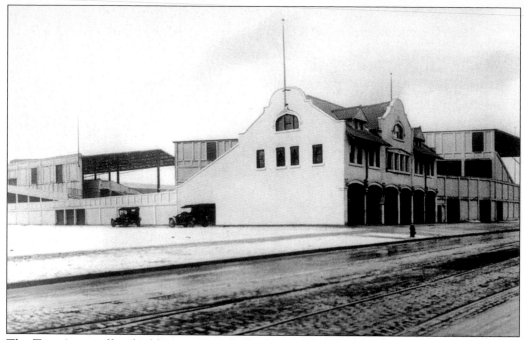

The Tigers' new office building on Trumbull connected to the stands at the right field corner at the new Navin Field. (Author's collection.)

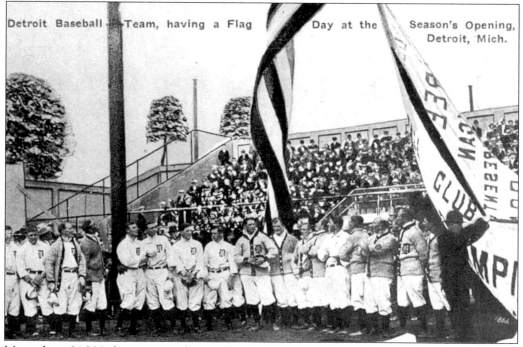

Detroit Baseball Team, having a Flag Day at the Season's Opening, Detroit, Mich.

More than 24,000 fans crammed into the 23,000 seat park. After an impressive flag-raising ceremony, Ty Cobb scored the first run ever at Navin Field by stealing home in the bottom of the first inning. The Tigers went on to beat Cleveland 6-5 in eleven innings. (Author's collection.)

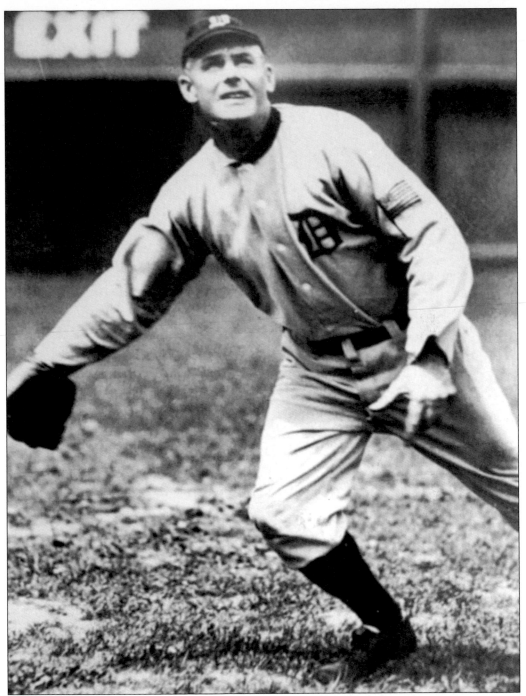

Outfielder Sam Crawford came to the Tigers in 1903 and starred as they made the transition to Navin Field. Crawford, nicknamed Wahoo after his little hometown in Nebraska, batted .378 in the last year of Bennett Park in 1911, and had a .325 average in Navin Field's first year. The popular Crawford spent his later years in Hollywood, where another boy from Wahoo, Daryl Zanuck, was a well-known movie producer. (Courtesy Burton Historical Collection of the Detroit Public Library.)

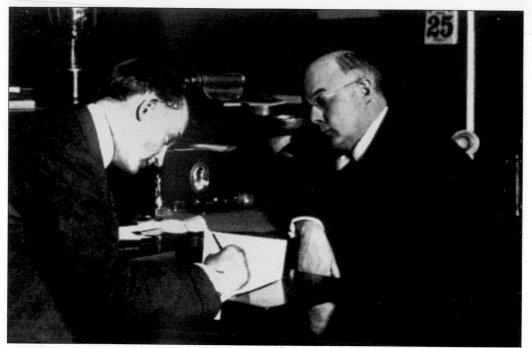

Ty Cobb had another great year in 1912, batting over .400 for the second year in a row. Owner Frank Navin signed Cobb to a $15,000 contract for 1913, making the fiery outfielder baseball's highest paid player. (Courtesy Burton Historical Collection of the Detroit Public Library.)

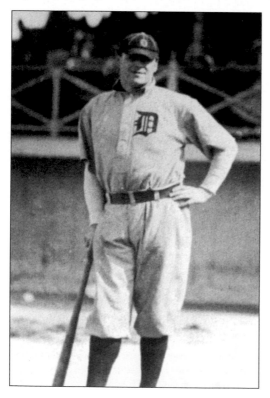

George Mullin pitched for the Tigers from 1902 through part of the 1913 season, winning 209 games. Mullin, a good hitter with a .263 career average, won 20 or more games five times for the Tigers. He held the club records for 20-win seasons, complete games, and innings pitched. (Courtesy Burton Historical Collection of the Detroit Public Library.)

The Tigers finished sixth their first two seasons at Navin Field, improved to fourth in 1914, and placed second in 1915 before dropping a notch each year in 1916 and 1917. Babe Ruth pitched a memorable game for the Red Sox against the Tigers on July 11, 1917. Ruth only allowed the Tigers one hit while winning 1-0. (Author's collection.)

Fans were allowed on the field and could exit through the right field wall to Trumbull after games. After slipping to seventh in 1918, the Tigers finished fourth the following year before slipping back to seventh again in 1920. Hughie Jennings, manager since 1907, was fired and replaced by Ty Cobb. (Courtesy Burton Historical Collection of the Detroit Public Library.)

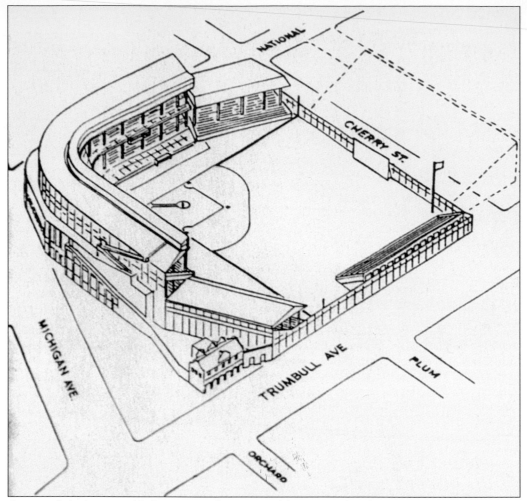

A second deck was added to part of Navin Field in time for the 1923 season, increasing seating capacity to close to 30,000. For larger crowds, the Tigers roped off the area between the right center field bleachers and the right field corner, allowing fans to stand on the field. (Courtesy Marc Okkonen.)

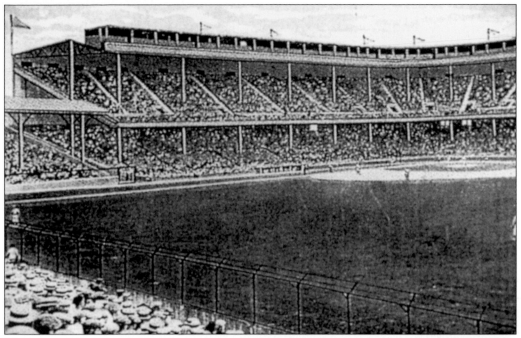

36,000 turned out for the 1923 home opener and the Tigers, under third-year manager Ty Cobb, finished second. The team drew 911,377 for the season, the highest attendance ever and the first time the club drew more than 900,000. (Author's collection.)

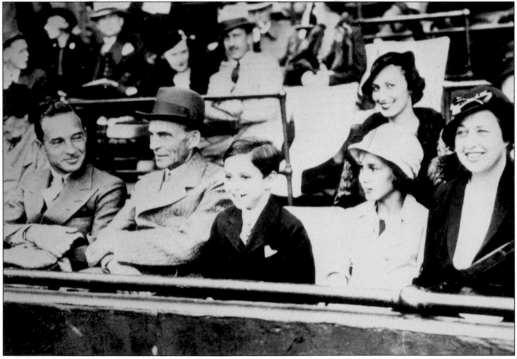

Three generations of Detroit's most famous family. Henry Ford, flanked by his son Edsel and grandson Henry, had front row seats at Navin Field. (Courtesy Michigan Views.)

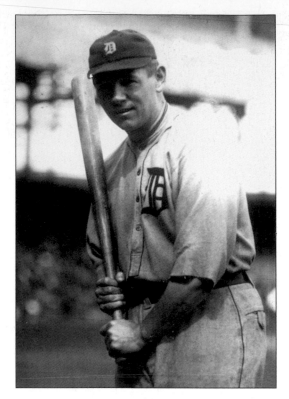

Harry Heilmann was one of the best hitters of the 1920s. From 1921 to 1927, Heilmann won four batting championships with marks of .394, .403, .393, and .398. He became the Tigers' play-by-play man for 17 years and died at the age of 56, a day before Detroit hosted the 1951 All-Star Game. (Courtesy collection of Christopher Galli.)

One of the most popular Tigers in the 1920s was outfielder Bob "Fatty" Fothergill. He batted over .300 for eight consecutive seasons from 1922 to 1929. (Courtesy Burton Historical Collection of the Detroit Public Library.)

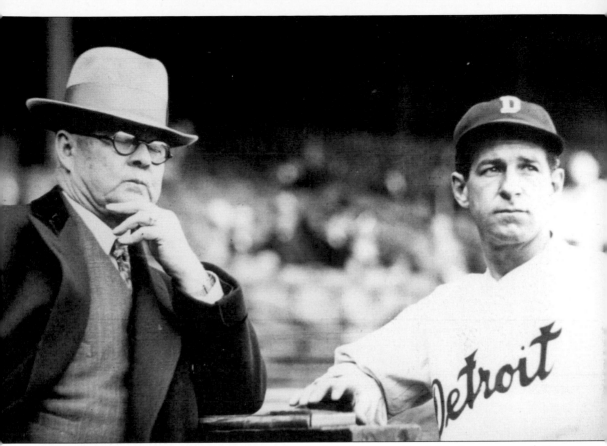

After the 1926 season in which the Tigers finished sixth, owner Frank Navin announced Ty Cobb's retirement as a player and manager. Former Tigers third baseman George Moriarty was brought in to manage, but after the 1928 season when the club won only 68 games and attendance dipped below 475,000, Navin brought in Bucky Harris for the 1929 season. Harris was called the "Boy Wonder" after he led the Washington Senators as player-manager to the 1924 World Series at the age of 27. (Courtesy Burton Historical Collection of the Detroit Public Library.)

1930 was the third consecutive season that Tigers' second baseman Charlie Gehringer played in every single game and the fourth season in which he batted over .300. In his 19-year career with the Tigers, Gehringer would compile a .320 lifetime average. (Courtesy collection of Christopher Galli.)

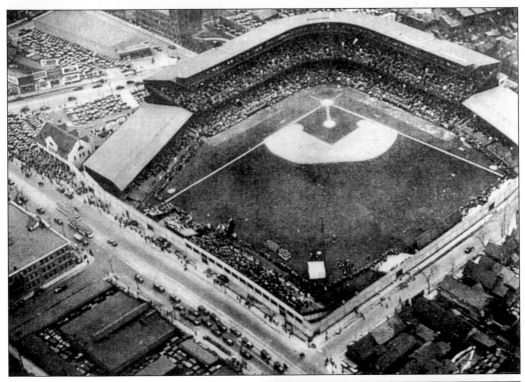

Under Bucky Harris, the Tigers bounced between seventh and fifth place. Attendance in hard-hit, Depression-era Detroit was only 320,972 in 1933, and Navin made another managerial change. (Courtesy Burton Historical Collection of the Detroit Public Library.)

Catcher Mickey Cochrane was purchased from Philadelphia in the winter of 1933. Owner Connie Mack was selling players to pay bills brought on by the Depression. To save an extra salary, the Tigers asked Cochrane to serve as player-manager, and he excelled in both roles. Cochrane, nicknamed "Black Mike" because he always got his uniform dirty, hit .320 in 1934 and .319 in 1935, leading the Tigers to the World Series both years. (Courtesy George Brace.)

The face on California Raisin boxes around the country for years was Violet Oliver, a former Miss California and Broadway chorus girl. In Detroit, however, she was famous for being the wife of Tigers pitcher Earl Whitehill. After ten years with the Tigers, Whitehill was traded to Washington in 1933. (Courtesy Burton Historical Collection of the Detroit Public Library.)

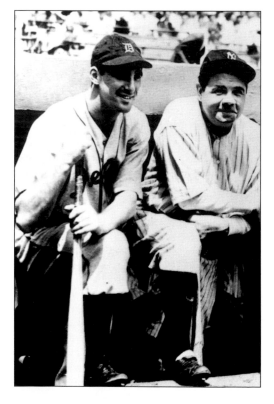

Babe Ruth's last visit to Detroit as a player was in 1934. Rising star Hank Greenberg happily picked up batting tips from Ruth. (Courtesy Burton Historical Collection of the Detroit Public Library.)

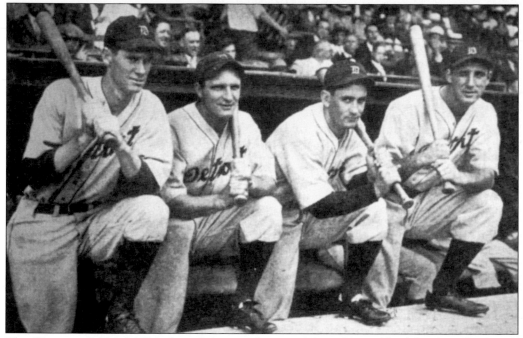

The Tigers infield of 1934, from left to right, was Marv Owen (third base), Billy Rogell (shortstop), Charlie Gehringer (second base), and Hank Greenberg (first base). Owen drove in 96 runs, while the rest of the infield had 100 or more runs batted in. Greenberg missed one game during the season, while the others played in every single game. (Courtesy Burton Historical Collection of the Detroit Public Library.)

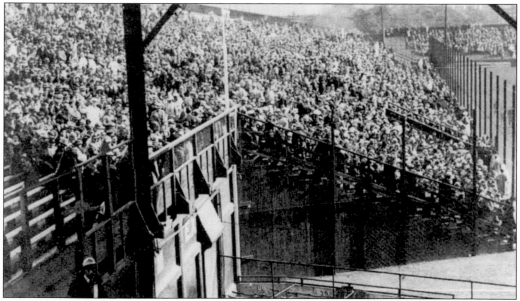

Temporary bleachers beyond left field were built during the 1934 season to accommodate larger crowds as the Tigers fought for the pennant. Frank Navin's investment paid off as fans poured in to watch the World Series against the St. Louis Cardinals. (Courtesy Burton Historical Collection of the Detroit Public Library.)

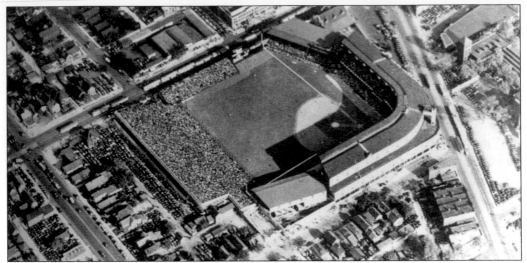

Navin Field hosted crowds of over 40,000 for all four World Series games played in Detroit. (Courtesy Manning Brothers Historic Photographic Collection.)

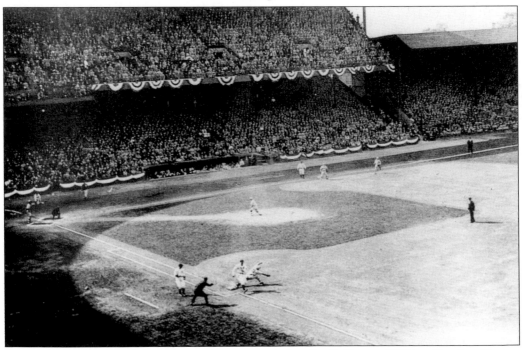

Among the paying fans were many celebrities, including Joe E. Brown, William Frawley, George Jessell, George Raft, and Will Rogers. Henry Ford and Babe Ruth were among several nationally known people soaking up the atmosphere. (Courtesy Burton Historical Collection of the Detroit Public Library.)

With the Series tied, a festive air prevailed prior to game seven. However, Dizzy Dean and the Cardinals humiliated the Tigers and were ahead 7-0 after the third inning. In the sixth, Joe Medwick tripled and slid hard into Marv Owen, toppling the Tigers' third baseman. The unhappy fans among the 40,902 in attendance protested loudly as St. Louis added two more runs. When Medwick headed to his left field position, thousands of fans in the wooden bleachers stood, jeered, and started targeting Medwick with fruit. The Cardinals left fielder retreated closer to the infield until order was restored. Medwick returned to his position and the ugly scene was repeated and worsened. Commissioner Judge Kennesaw Mountain Landis conferred with the managers and umpires and ruled Medwick out of the game to stave off a riot. The game resumed and the Cardinals scored two more to drub the Tigers 11-0. The loss and the incident were a negative ending to the great 1934 season. (Courtesy Burton Historical Collection of the Detroit Public Library.)

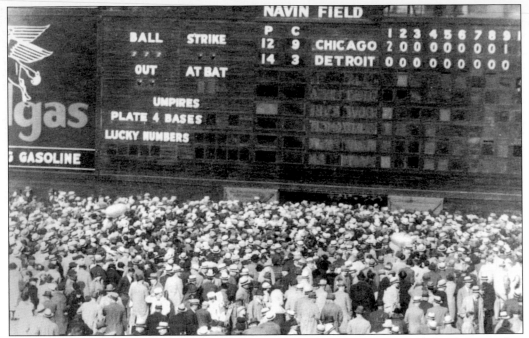

The pennant-winning Tigers drew 1,034,929 fans for the 1935 season, and for the very first time in franchise history they won the World Series, defeating the Chicago Cubs in six games. (Courtesy Burton Historical Collection of the Detroit Public Library.)

Frank Navin had his first championship team in 30 years of ownership. However, a month later he suffered a heart attack and died at the age of 64. (Courtesy Burton Historical Collection of the Detroit Public Library.)

Co-owner Walter O. Briggs assumed full control of the club and ballpark and added seating by double-decking the stands along the foul lines and the outfield. (Courtesy Burton Historical Collection of the Detroit Public Library.)

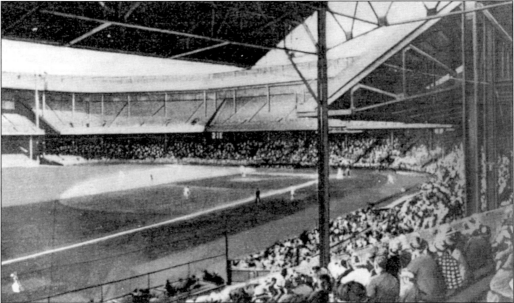

The stands were double-decked along the first base line and into right field for the 1936 season. Slugger Hank Greenberg played in only twelve games as a wrist injury sidelined him for the season. The Tigers dropped out of the pennant race early and drew less than 876,000 fans. (Author's collection.)

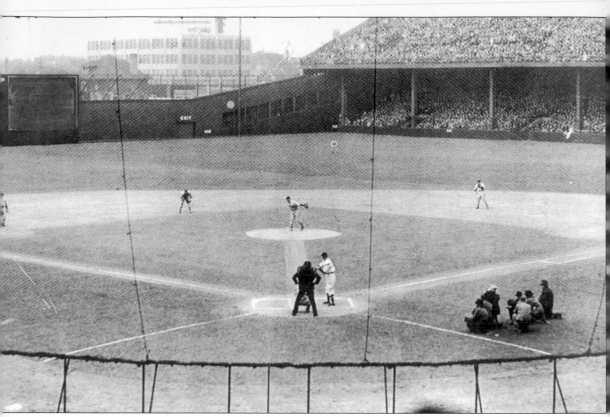

Many photographers closely covered the Tigers. Hank Greenberg was back for the 1937 season and played in every game, batting .337 with 40 home runs and an amazing 183 RBIs. The Tigers placed second for the second year in a row but won six more games and bettered the previous year's attendance by almost 200,000. The expansion continued and owner Walter O. Briggs changed the name of the ballpark from Navin Field to Briggs Stadium. (Courtesy Burton Historical Collection of the Detroit Public Library.)

THREE

Briggs Stadium
1938–1960

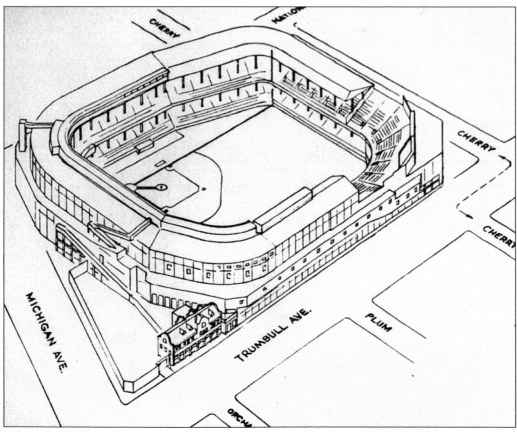

When the final expansion was completed, the home of the Tigers had more than 53,000 seats and the only double-decked bleachers in the major leagues. (Courtesy Marc Okkonen.)

The Tigers slipped to fourth place and attendance dipped below 798,000. Unhappy owner Walter O. Briggs fired manager Mickey Cochrane in August and replaced him with coach Del Baker. The season's bright spot was big first baseman Hank Greenberg, who hit 58 home runs while batting .315. (Courtesy George Brace.)

Acquired from Boston in 1939, Mike "Pinky" Higgins nailed down the third base position for the next six seasons, compiling a steady .280 batting average. (Courtesy Burton Historical Collection of the Detroit Public Library.)

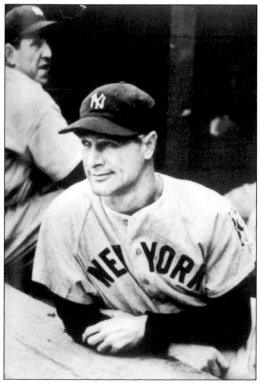

After playing in 2,130 consecutive games, Lou Gehrig took himself out of the lineup on May 2, 1939, and watched the game from the visitors' dugout at Briggs Stadium. (Courtesy Burton Historical Collection of the Detroit Public Library.)

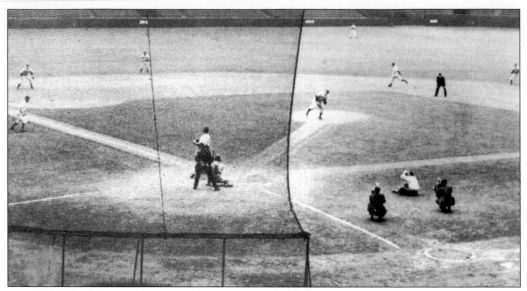

The Tigers sank a notch to fifth in 1939. Pitcher Bobo Newsom was 3-1 when acquired from St. Louis in May and finished the season with a 20-11 record, tying for the American League lead in complete games and placing second in strikeouts. (Author's collection.)

After ten seasons with the Tigers, popular shortstop Billy Rogell would finish his career with the Cubs in 1940. (Courtesy B&W Photos.)

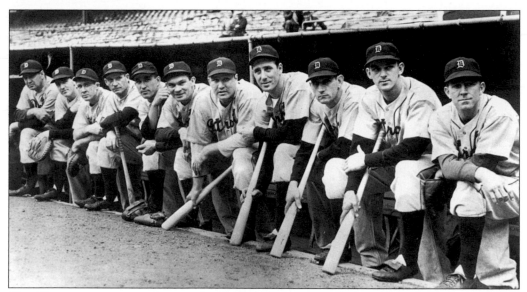

The Tigers were eager to have a better season in 1940 and made some defensive changes. Catcher Rudy York was moved to first base, and first baseman Hank Greenberg moved to left field. Key players posed on opening day. From left to right are pitcher Bobo Newsom, catchers Billy Sullivan and Birdie Tebbetts, outfielders Pete Fox and Bruce Campbell, third baseman Pinky Higgins, York, Greenberg, second baseman Charlie Gehringer, center fielder Barney McCosky, and shortstop Dick Bartell. (Courtesy B&W Photos.)

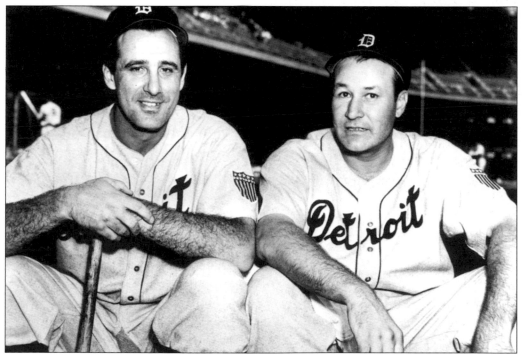

Hank Greenberg, left, led the league in 1940 with 41 home runs and 150 RBIs, and his .340 batting average helped him earn the Most Valuable Player award. Rudy York, playing in every game in his new position, hit 33 hone runs and drove in 134 runs. (Courtesy B&W Photos.)

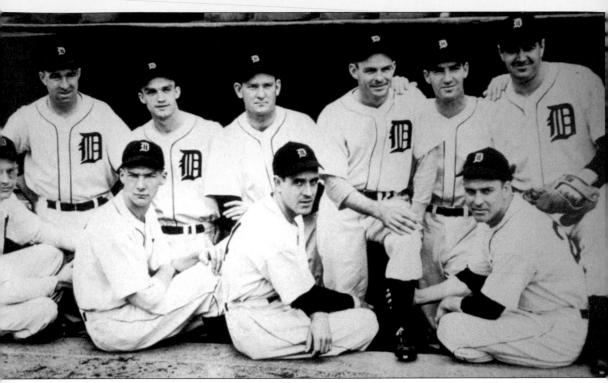

The 1940 pitching staff had a 90-64 record for the pennant-winning Tigers. The leading pitchers were Bobo Newsom (21-5) and Schoolboy Rowe (16-3). Pictured from left to right, are: (standing) Lynn Nelson, John Gorsica, Al Benton, Tommy Bridges, Rowe, and Newsom; (sitting) Dizzy Trout, Hal Newhouser, Tom Seats, and Archie McKain. (Courtesy Burton Historical Collection of the Detroit Public Library.)

On October 6, 1940, a record crowd
of 55,189 saw Bobo Newsom win his
second World Series game by shutting
out the Reds in the fifth game. With
the Tigers ahead three games to two,
the Series shifted to Cincinnati, but
the Tigers were shut out in game six.
Newsom only allowed the Reds two
runs in game seven but the Tigers only
managed to score one run. (Courtesy
Burton Historical Collection of the
Detroit Public Library.)

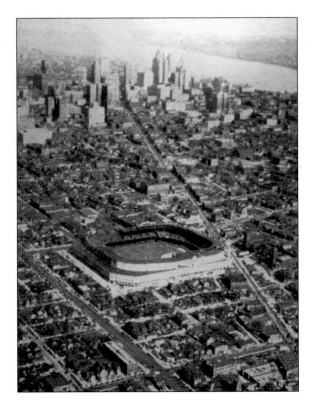

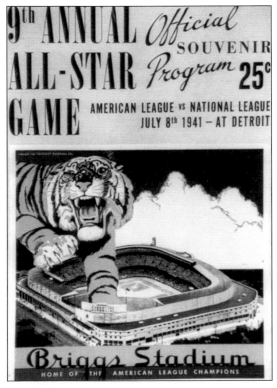

Ted Williams, who two years earlier was
the first player ever to hit a fair ball out of
Briggs Stadium, homered in the bottom
of the ninth in the 1941 All-Star Game,
giving the American League a thrilling 7-5
victory. (Author's collection.)

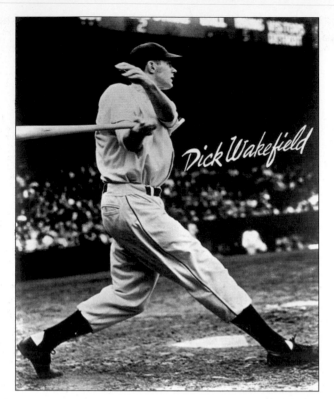

The Tigers outbid ten other teams and signed bonus baby Dick Wakefield off the University of Michigan campus in 1941 for $52,000 and a new Lincoln automobile. However, it was a terrible year for the Tigers. Hank Greenberg was drafted into the army 19 games into the season, and Bobo Newsom lost 20 games. The team finished fourth, 26 games out of first. (Courtesy Sports Legends Photos, Inc.)

Billy Rogell, who was with the Tigers in the 1930s, started a 38-year political career as a Detroit city councilman in 1942. (Courtesy Jim Campbell.)

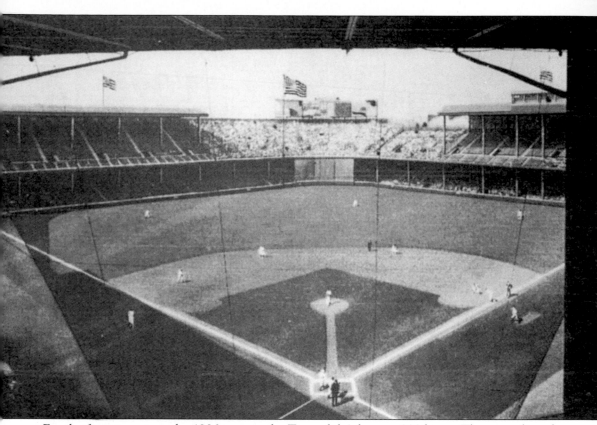

For the first time since the 1906 season, the Tigers didn't have a .300 hitter. The team slipped to fifth and attendance dipped to 580,000 as more players and fans were serving in the armed forces, resulting in smaller crowds. It was another fifth place finish and low attendance year in 1943, and Steve O'Neill replaced Del Baker as manager. In 1944 attendance improved by over 300,000 as Hal Newhouser emerged as the club's star pitcher by winning 29 games. Dick Wakefield, granted a 90-day leave by the Navy, played in 78 games and batted .355 with 12 home runs in only 276 at-bats as the Tigers came within one game of the pennant.

Hal Newhouser starred again in 1945 as he won 25 games. Hank Greenberg returned from four-and-a-half years in the service in July and helped propel the Tigers into the World Series. (Courtesy George Brace.)

A new Detroit record crowd of 55,500 attended game three of the 1945 World Series. Despite losing the first game, Newhouser won his next two starts and Greenberg collected two home runs and three doubles as the Tigers defeated the Chicago Cubs in seven games. (Courtesy Burton Historical Collection of the Detroit Public Library.)

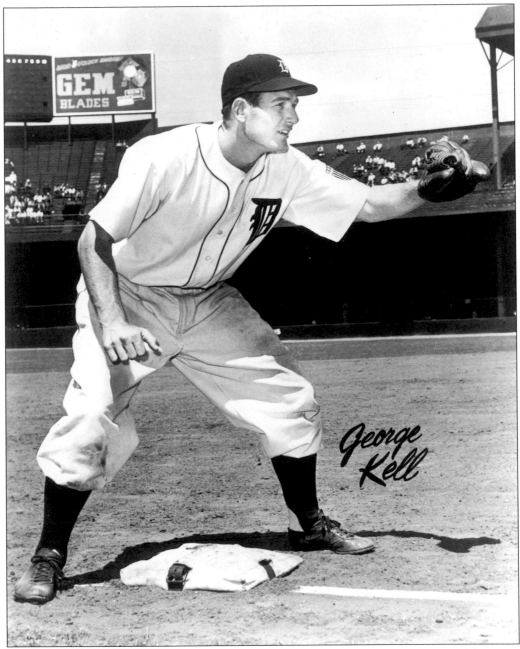

Home towner Barney McCosky was traded to the Philadelphia Athletics for third baseman George Kell. Kell proceeded to hit .327 and go on to be one of the most popular players ever to play for the Tigers. (Courtesy Sports Legends Photos.)

The Tigers finished second in 1946 and 1947. An all-time stadium record crowd of 58,369 paid their way in for a doubleheader against the Yankees on July 20, 1947. After the season, lights were installed and seven night home games were scheduled in 1948. (Courtesy Burton Historical Collection of the Detroit Public Library.)

The first night game at Briggs Stadium, played on June 15, 1948, drew 54,480 fans as Hal Newhouser pitched the Tigers to a 4-1 victory over the Philadelphia Athletics. (Author's collection.)

The Tigers had many different shortstops in the 1940s. Eddie Lake held the job in 1946 and 1947 but became a valuable utility player at all infield positions for the team over the next several seasons. (Courtesy Sports Legends Photos.)

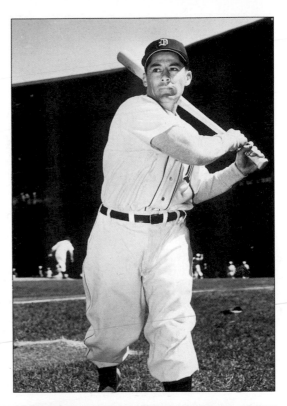

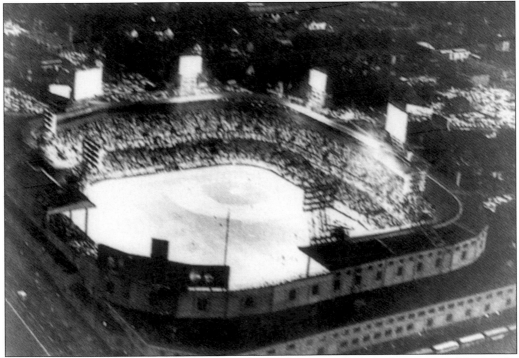

A Detroit-Cleveland match up on August 9, 1948, drew 56,586 fans, the largest crowd for a night game in club history. (Courtesy Burton Historical Collection of the Detroit Public Library.)

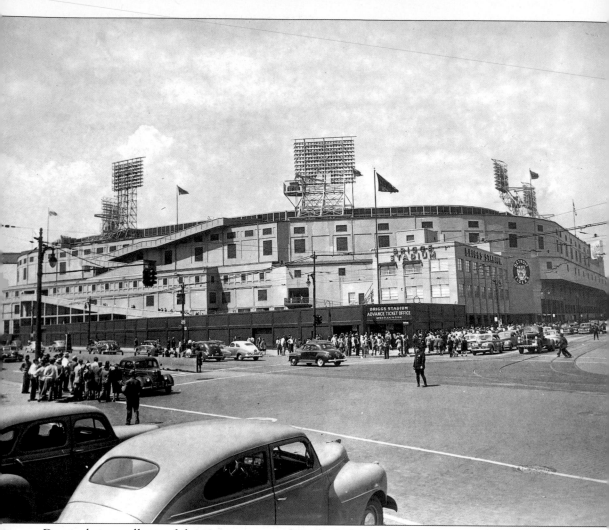

Despite being well out of the pennant race, when the Indians came to town crowds were larger than normal. An afternoon game with Cleveland drew 57,588 on September 26, 1948, the largest turnout ever for a single day game in Detroit. (Courtesy Burton Historical Collection of the Detroit Public Library.)

It was a strong fourth place finish for the Tigers in 1949 under new manager Red Rolfe. Another bright spot came on the last day of the season as George Kell's two hits raised his average to .3429, edging Ted Williams' .3427 for the American League batting championship. (Courtesy George Brace.)

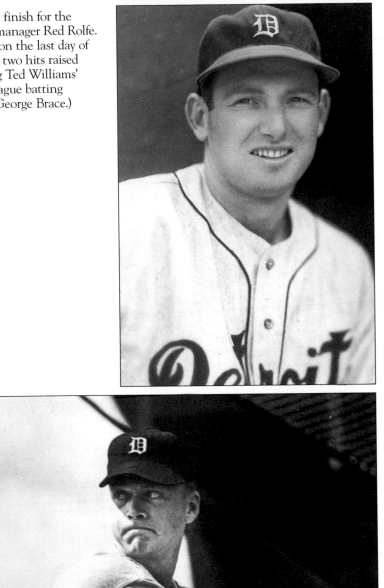

A new season record attendance of 1,951,474 saw the improved Tigers in 1950. The team was in first place as late as September 15 before slipping three games out when the season ended. Left fielder Hoot Evers, who had batted over .300 the past two years, starred by hitting .323 with 21 home runs and 103 RBIs. (Courtesy Sports Legends Photos, Inc.)

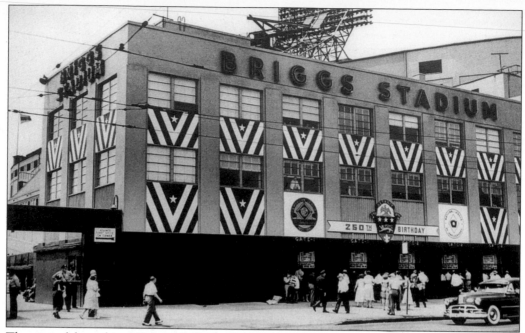

The city celebrated its 250th birthday in 1951 and Briggs Stadium hosted the All-Star Game on July 10. (Courtesy Burton Historical Collection of the Detroit Public Library.)

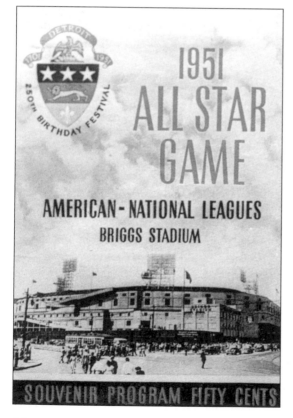

A crowd of 52,075 saw the National League win 8-3 despite home runs by George Kell and Vic Wertz of the Tigers. (Author's collection.)

Right fielder Vic Wertz was the Tigers' leading home run hitter for three consecutive seasons. When his 17-year career ended 12 years later, he returned to Detroit and became a respected and charitable businessman until his death in 1983. (Courtesy Sports Legends Photos, Inc.)

A familiar sight near the Tigers' dugout, rain or shine, owner Walter O. Briggs died early in 1952. His son, Spike, took over as team president. (Courtesy Burton Historical Collection of the Detroit Public Library.)

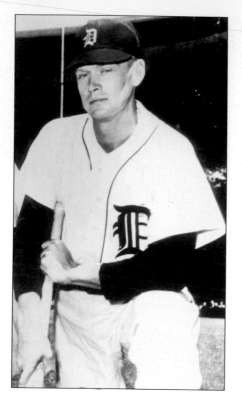

Hoot Evers was hoping for a better season in 1952. After three .300-plus seasons, Evers' batting average dropped a whopping 99 points to .224 in 1951 and the club fell to fifth place. (Courtesy B&W Photos.)

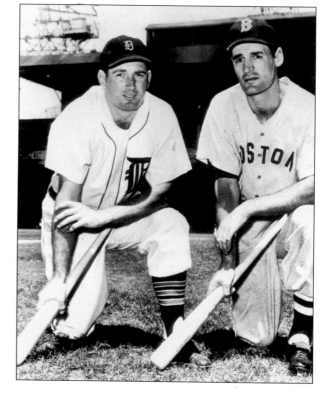

When the Red Sox came to Detroit, Walt Dropo sought some batting tips from George Kell. In 1950 the big Boston slugger hit 34 home runs and batted .322. In '51 he dropped to .239 with only 11 home runs. A short time later, Kell and Dropo would be switching uniforms in a big trade. (Courtesy B&W Photos.)

The Tigers lost their first eight games in 1952, were entrenched in last place early in the season, and stayed there. A whopping trade with Boston sent George Kell, Hoot Evers, Johnny Lipon, and Dizzy Trout packing in exchange for Walt Dropo and three others. Vic Wertz and other fan favorites were traded later in the season, but the Tigers couldn't deal themselves out of last place. The change of uniforms didn't hurt Kell's hitting as he maintained his usual .300-plus average. Dropo became the Tigers' regular first baseman and ended the season with 29 home runs and a .276 average. (Courtesy B&W Photos.)

Virgil Trucks won only five games and lost 19 in 1952. Amazingly, two of his five wins were no-hitters and one was a one-hitter. (Courtesy Sports Legends Photos, Inc.)

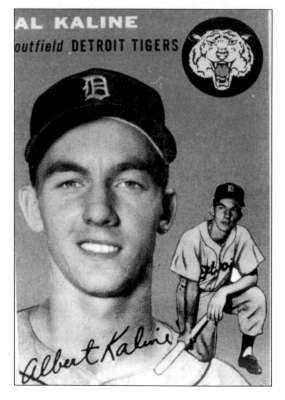

Sixth and fifth place finishes followed and manager Fred Hutchinson left after he was denied a two-year contract. Bucky Harris, who had managed the Tigers before from 1929 to 1933, was hired for 1955 and guided the team to another fifth place finish. The bright spot of the season was 20-year-old Al Kaline. The lanky right fielder surprised the baseball world by winning the American League batting championship with a .340 average, hitting 27 hone runs. (Courtesy Sy Berger Topps.)

58

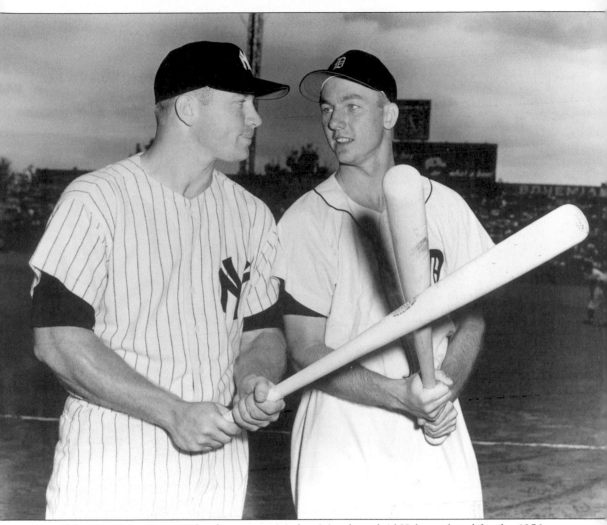

Two of the American League's brightest stars, Mickey Mantle and Al Kaline, played for the 1956 All-Stars at Griffith Stadium in Washington. Kaline had another fine season, batting .314 with 27 home runs and 128 RBIs. While the Tigers had three players who hit over .300, three players with 25 or more home runs, and two 20-game winning pitchers, the team finished in fifth place. Bucky Harris, who had managed five teams over a 29-year span, retired, and Jack Tighe was brought up from the minor league system to manage in 1957. (Courtesy B&W Photos.)

Hockey superstar Gordie Howe was quite a pitcher in his native Canada and was even offered a contract with the Yankees. Howe enjoyed working out with the Tigers between hockey seasons. (Courtesy collection of Hal Middelsworth.)

Jim Bunning emerged as a top pitcher in 1957 and was named the starting pitcher at the All-Star Game in St. Louis. The 25-year-old Bunning responded by retiring all nine batters he faced. He finished the season with a 20-8 record and a sparkling 2.69 ERA as the club finished fourth. (Courtesy Hal Middelsworth.)

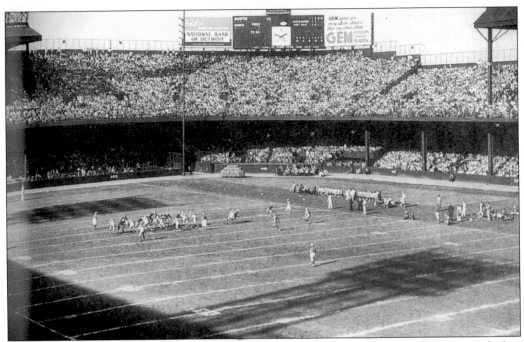

The Detroit Lions, who played their first game at Briggs Stadium on September 9, 1938, before 17,000 spectators, attracted 55,263 fans on December 29, 1957, for the NFL championship game. The Lions won the championship game over the Cleveland Browns 59-14. (Courtesy Burton Historical Collection of the Detroit Public Library.)

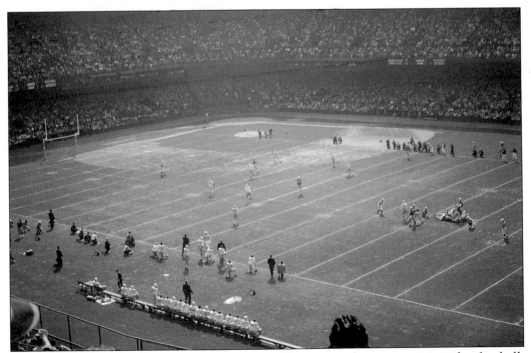

The upper deck bleachers in right center field were good vantage points for football. (Author's photo.)

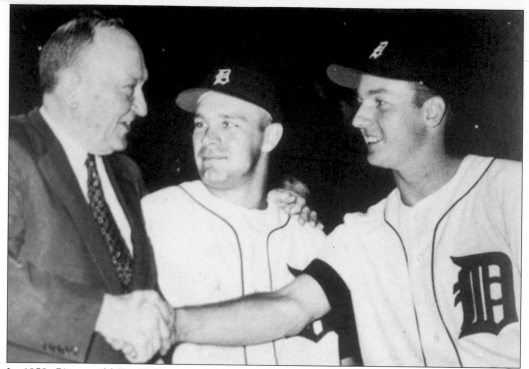

In 1958, 71-year-old Ty Cobb visited Briggs Stadium and shared batting tips with the Tigers' best two hitters—Harvey Kuenn and Al Kaline. (Courtesy Burton Historical Collection of the Detroit Public Library.)

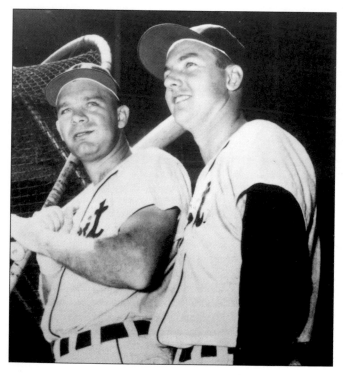

Kuenn batted .319 and Kaline batted .313 in 1958. The following season Kuenn would win the American League batting title with a .353 average. (Courtesy B&W Photos.)

In 1959 Larry Doby, who had broken the color barrier in the American League with Cleveland in 1947, became the first African American to play for the Tigers. Ozzie Virgil, a black player from the Dominican Republic, spent part of the 1958 season with the Tigers. There were changes in managers, too, but the team couldn't manage to rise above fourth as the decade ended. (Courtesy Jim Campbell.)

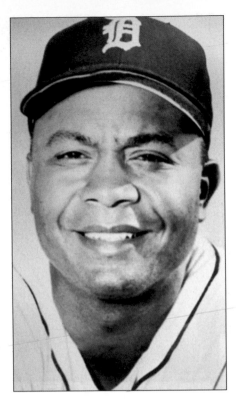

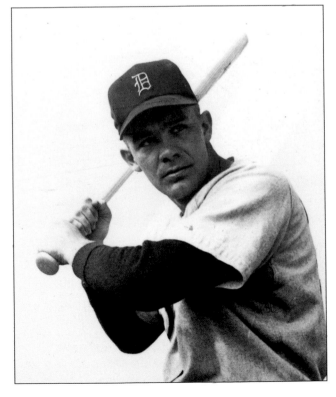

Shortly before the 1960 season began, the Tigers surprised the baseball world by dealing batting champ Harvey Kuenn to Cleveland for slugger Rocky Colavito, who had hit a league-leading 42 homers in 1959. (Courtesy B&W Photos.)

Colavito was stunned and Cleveland fans were outraged over the trade. Colavito, who enjoyed matinee idol status in Cleveland, hit .249 with 35 homers for the Tigers in 1960, while Kuenn hit .308 with nine home runs for the Indians. (Photo by author.)

Four

Tiger Stadium
1961–1999

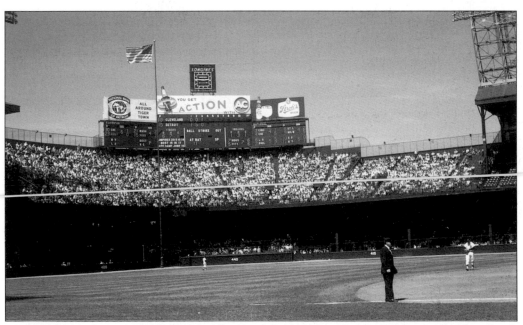

Briggs Stadium was renamed Tiger Stadium on the first day of 1961. It was a sixth place finish the previous year despite the shocking trade of managers. Tigers skipper Jimmy Dykes was traded to Cleveland in August for their manager Joe Gordon. The trade didn't help either team as each manager won 26 games with their new club and lost over 30. 1961 was a good year at Tiger Stadium, however. The larger scoreboard installed in 1958 provided shade for more fans and attendance increased by over 430,000 as new skipper Bob Scheffing piloted the club to second place. (Photo by author.)

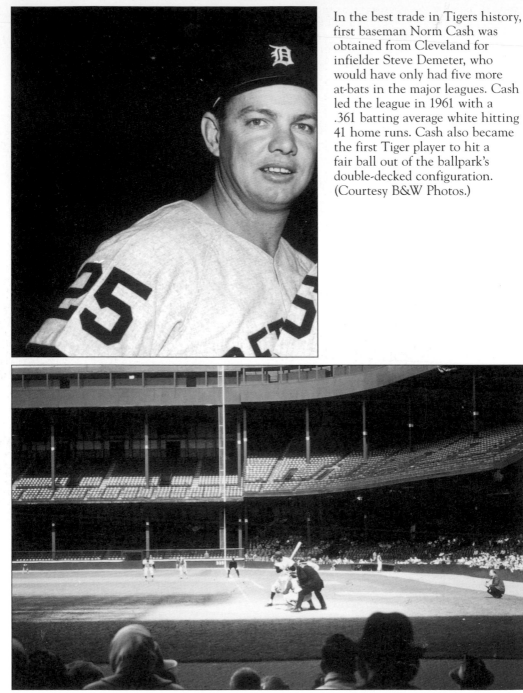

In the best trade in Tigers history, first baseman Norm Cash was obtained from Cleveland for infielder Steve Demeter, who would have only had five more at-bats in the major leagues. Cash led the league in 1961 with a .361 batting average white hitting 41 home runs. Cash also became the first Tiger player to hit a fair ball out of the ballpark's double-decked configuration. (Courtesy B&W Photos.)

On June 24, 1962, the Tigers lost a seven-hour, 22-inning game to the Yankees. Most fans exited before the Yankees' Jack Reed hit the only home run of his career, downing the Tigers 9-7. Things went downhill as the club ended the season in fourth place. They were entrenched in eighth place the following June when Charlie Dressen replaced Bob Scheffing. The team responded by finishing in a tie for fifth, then followed with fourth place finishes in 1964 and 1965. (Photo by author.)

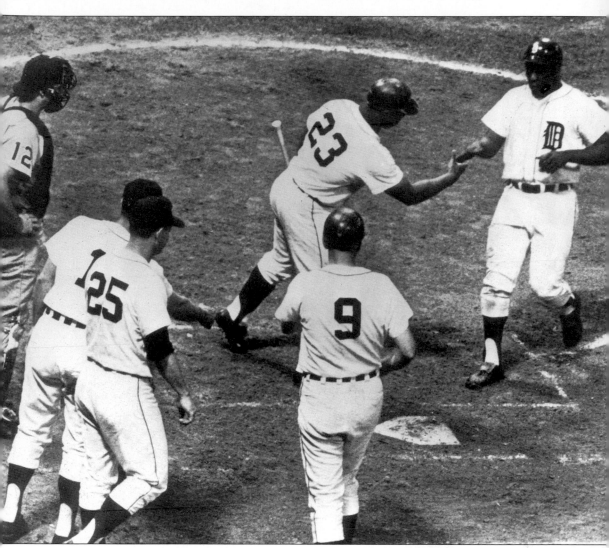

In 1965 outfielder Gates Brawn broke in with some key hits. Here Brown is greeted by Willie Horton as he scores after hitting a home run with the bases loaded. Waiting for Brown are Ray Oyler, Norm Cash (25) and Jerry Lumpe (9). (AP photo from the collection of Dennis Jose.)

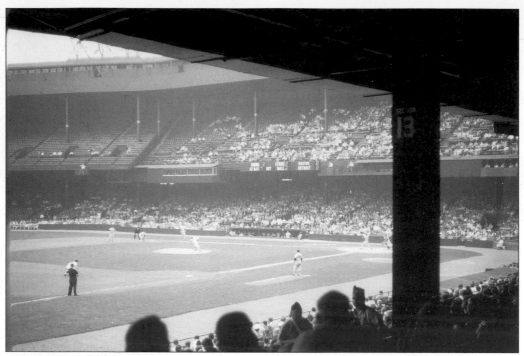

1966 was a year of bad news. Charlie Dressen, who had been sidelined by a heart ailment the previous season, suffered a heart attack and died in August. Bob Swift, who had taken over for Dressen before, assumed the role again until lung cancer forced him to step aside after compiling a winning 32-25 record. Coach Frank Skaff managed the last 79 games and the disheartened team wound up in third. More bad news followed shortly after the season as Swift, who played ten seasons for the Tigers before turning to coaching, died at the age of 51. (Photo by author.)

Mayo Smith, former National League manager and longtime scout for the Yankees, was named manager for the 1967 season. Smith kept the Tigers in the race until the last game of the season. (Courtesy Hal Middelsworth.)

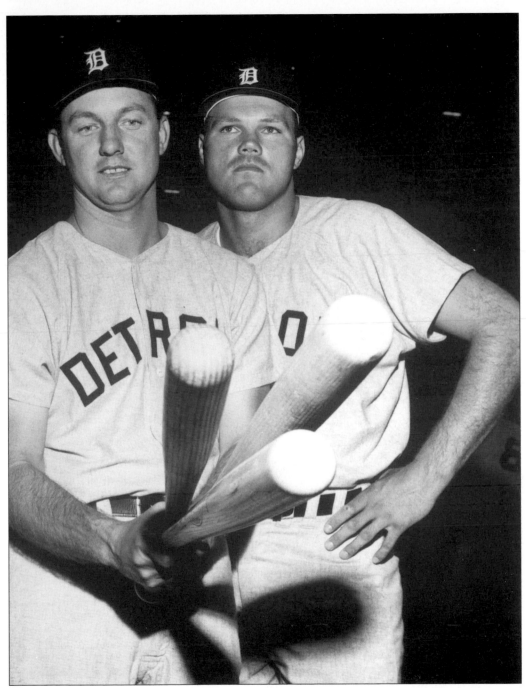

Al Kaline's .308 average and 25 home runs, along with catcher Bill Freehan's 20 homers and .282 average, helped keep the Tigers in the 1967 pennant race. (Courtesy B&W Photos.)

Denny McLain's phenomenal 1968 season, when he won 31 games and lost only six while posting a low ERA of 1.96, led the Tigers to the World Series. McLain hosted a popular Detroit talk show after his playing career, but then opted for other opportunities that led to two prison terms. (Courtesy B&W Photos.)

Mickey Lolich had a 17-9 record to go along with a 3.19 ERA. However, in the World Series, while McLain won one game and lost two, Lolich won all three of his starts and led the Tigers to a world championship. (Courtesy B&W Photos.)

The World Series went a full seven games and games three, four, and five were played in Detroit. Each game attracted the same 53,634 attendance numbers. (Author's collection.)

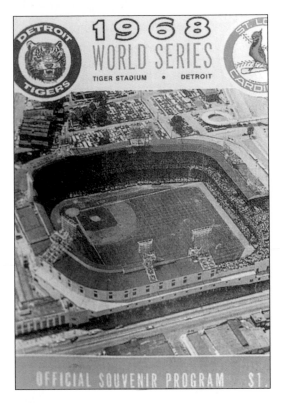

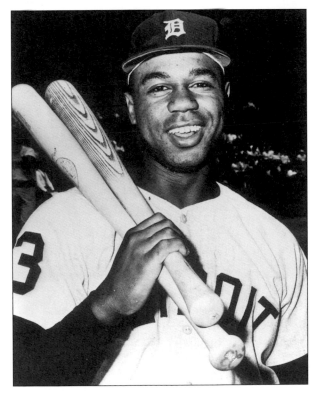

Affable slugger left fielder Willie Horton hit 36 home runs in 1968. In game five with St. Louis ahead three games to one, Horton made the most memorable defensive play in the history of the ballpark when he threw out speedster Lou Brock trying to score from second on a single. (Courtesy B&W Photos.)

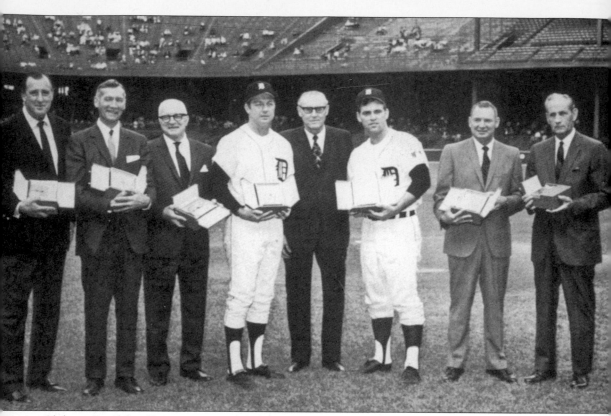

Club owner John Fetzer is surrounded by a reunion of the living members of the Tigers' all-time greatest players. From left to right are Hank Greenberg (first base), Hal Newhouser (left hand pitcher), Billy Rogell (shortstop), Al Kaline (outfield), Fetzer, Denny McLain (right hand pitcher), George Kell (third base), and Charlie Gehringer (second base). Outfielders Ty Cobb and Harry Heilmann were deceased. (Courtesy Hal Middelsworth.)

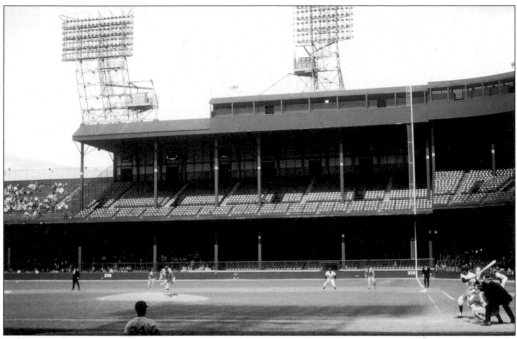

Even though Denny McLain won 24 games and Mickey Lolich 19, attendance dropped by over 450,000 in 1969 as the Tigers dropped to a distant second, 19 games out of first. (Photo by author.)

Mayo Smith was fired after the Tigers finished fourth in 1970. Denny McLain, who was suspended three times and won only three games, was packaged in a post-season trade that brought third baseman Aurelio Rodriguez, shortstop Ed Brinkman, and pitcher Joe Coleman to Detroit. (Photo by author.)

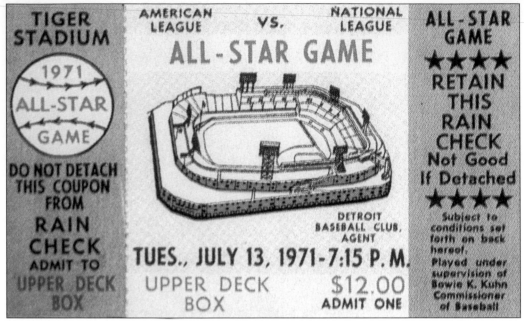

Detroit hosted the All-Star Game for the third time, and 53,559 saw the American League win 6-4. Reggie Jackson hit one of the most memorable home runs in stadium history as his towering shot struck the light tower on the edge of the roof near the upper deck bleachers in right-center field. (Author's collection.)

Fiery new manager Billy Martin guided the Tigers to a second place finish in 1971, followed by a playoff spot in the American League Championship Series in 1972, where they lost the decisive game. (Courtesy Hal Middelsworth.)

Big (6'7") Frank Howard, a 15-year slugging veteran, joined the Tigers late in the 1972 season. The Tigers were expecting big numbers from Howard and Willie Horton in 1973, but the slugging pair had off years and only accounted for 29 homers. Stormy Billy Martin was fired with 19 games left in the season and coach Joe Schultz took over as the Tigers managed to finish third. (Courtesy B&W Photos.)

Because many of the Tigers of the 1960s were aging and the minor leagues were feeding in younger players, the team turned to patient, experienced Ralph Houk as manager. Houk worked well with the media and players, but the team finished in sixth place and the outlook was bleak. (Photo by author.)

The Detroit Lions played their last game at Michigan and Trumbull before 53,714 paying fans on November 28, 1974. (Photo by author.)

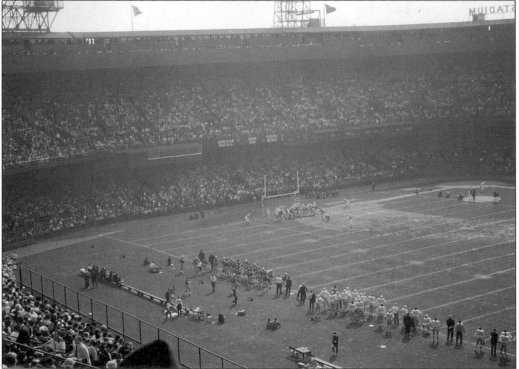

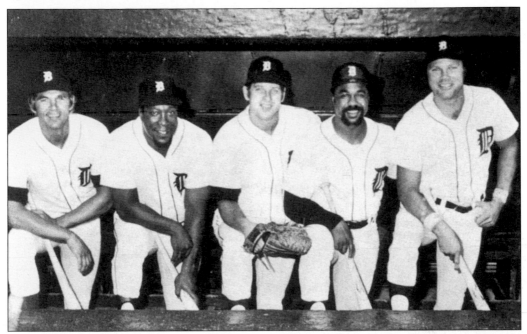

Recognition Day on September 14, 1975, honored players who participated in the 1968 World Series and 1972 American League Championship Series. From left to right are Mickey Stanley, Gates Brown, Mickey Lolich, Willie Horton, and Bill Freehan. (Courtesy Jim Campbell.)

There weren't many reasons to cheer in 1975 as the Tigers lost 19 straight games on their way to 102 losses and another last place finish. (Photo by author.)

Birdmania swept Detroit as rookie Mark "The Bird" Fidrych was compiling 19 wins and a low 2.34 ERA. Fans came to the ballpark in large numbers to watch "The Bird" on his knees smoothing the dirt around the pitching mound each inning, prancing around the infield congratulating mates on a good play, and talking to the ball before throwing it. Attendance was up over 400,000 even though the team was a distant fifth place finisher. (Courtesy Hal Middlesworth.)

Catcher Bill Freehan said goodbye after 15 years with the Tigers at the age of 35 and entered the business world in the Detroit area. (Photo by author.)

In 1977 first baseman Jason Thompson hit two balls over the right field roof twice in a month as he compiled 31 home runs. Mark Fidrych managed a 6-2 record as injuries shelved him for most of the season in which the club finished fourth, 26 games out. (Courtesy B&W Photos.)

Rusty Staub's 121 RBIs in 1978 was second best in the league and helped the Tigers to a strong fifth place finish. Injuries limited Mark Fidrych to a 2-0 record, while hope for the future came in the form of rookie infielders Alan Trammell and Lou Whitaker. (Courtesy B&W Photos.)

79

General Manager Jim Campbell, who had been with the Tigers organization since 1949, was elevated to president in 1978. Ralph Houk retired at the end of the season. Campbell promoted minor league manager Les Moss to replace Houk, but less than two months into the 1979 season, Campbell snagged Sparky Anderson to manage.

Writers in the press box were kept busy chronicling the changes. After finishing fifth in 1979 and 1980, followed by a couple of fourth place spots, Anderson's Tigers rose to second in 1983. (Photos by author.)

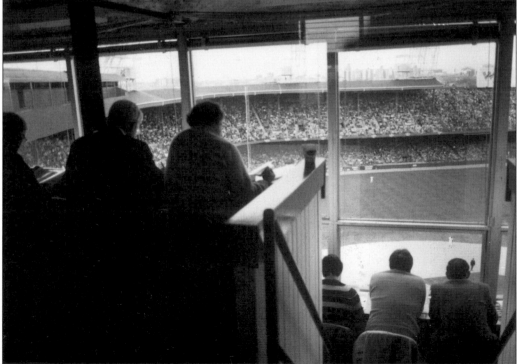

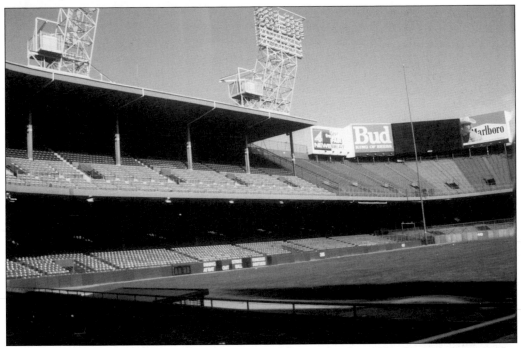

Stadium renovations started after the 1977 season were completed in 1983. A new lighting system and scoreboard were installed, and plastic orange and blue seats replaced wooden green ones.

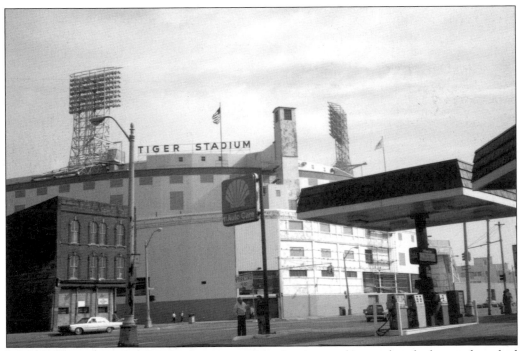

Renovations were completed when an outer aluminum skin replaced the pockmarked multi-layers of light gray paint around the exterior. (Photos by author.)

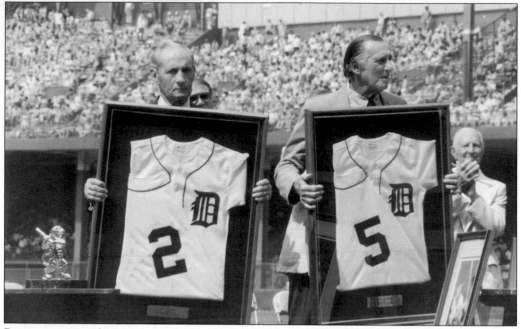

Between games of a June 1983 doubleheader, the Tigers retired the uniform numbers of Hall of Famers Charlie Gehringer (left) and Hank Greenberg. (Photo by author.)

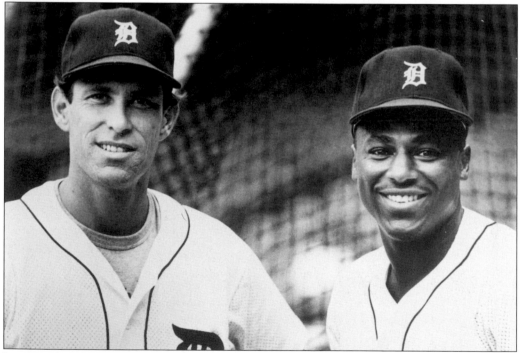

In 1983 the Tigers' all-star double-play combination of shortstop Alan Trammell (left) and second baseman Lou Whitaker hit .319 and .320, respectively. The pair had played in the minor leagues together and made their major league debut together in 1977. (Courtesy Sports Legend Photos, Inc.)

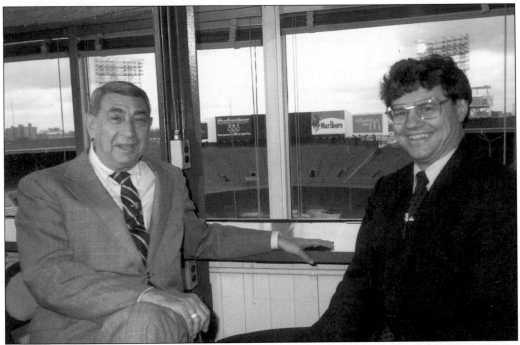

Domino's Pizza founder and owner Tom Monaghan bought the Tigers after the 1983 season for $53 million. With the Tigers off to a quick start in 1984, Howard Cosell (left) met Monaghan for an interview in the Tiger Stadium press box.

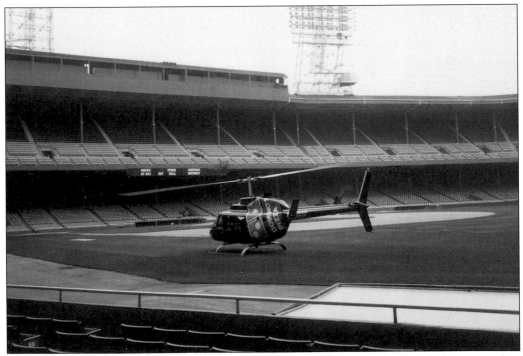

Monaghan came from his Ann Arbor headquarters to Tiger Stadium by helicopter, often landing in short right field as it was closest to Tigers' offices. (Photos by author.)

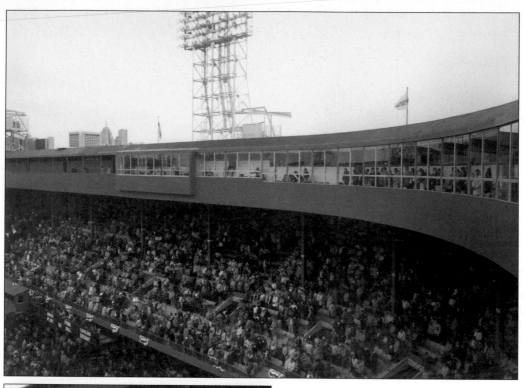

The Tigers won their first nine games in 1984, and by the time they won 35 out of 40, advance ticket sales were at an all-time high. Seats in the press box on the roof also were usually filled.

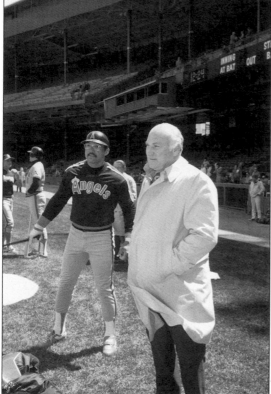

When the California Angels came to town, broadcaster Harmon Killebrew told Reggie Jackson about the home run he hit over the left field roof off Jim Bunning 22 years earlier. (Photos by author.)

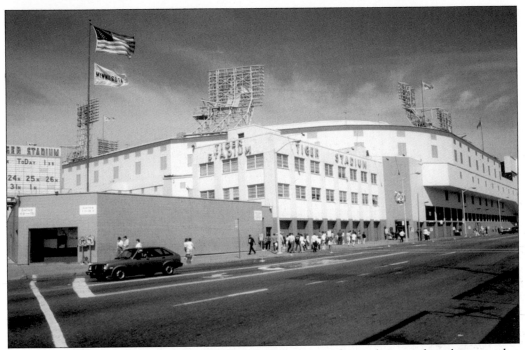

Even on off days in 1984, groups of fans made their way to the stadium to the advance ticket window. (Photo by author.)

Dan Petry, with the Tigers since 1979, had his best year in 1984 when he had an 18-8 record with a 3.24 ERA. (Courtesy B&W Photos.)

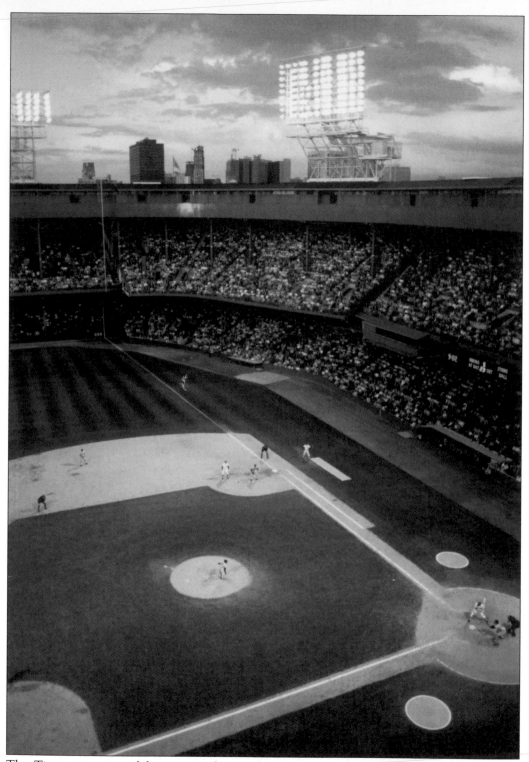

The Tigers set a record home attendance of 2,704,794 on their way to a franchise record 104 wins during the 1984 season. (Photo by author.)

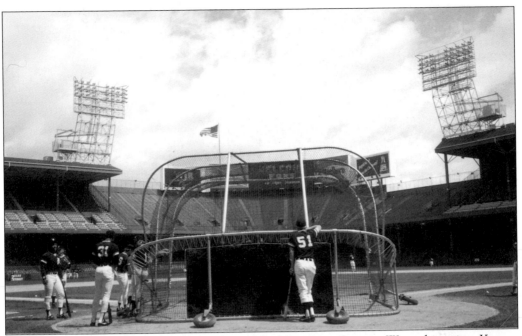

The Tigers readied for the playoffs against the American League West champion Kansas City Royals.

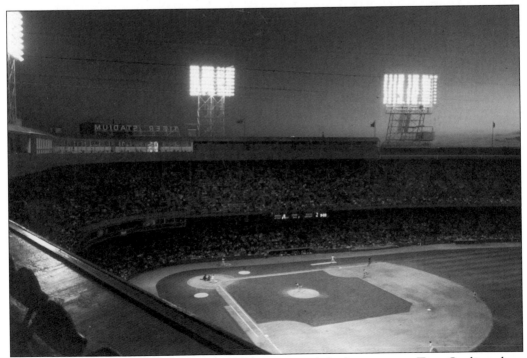

The Tigers swept the Royals in three straight games, and the lone game at Tiger Stadium drew 52,168. (Photos by author.)

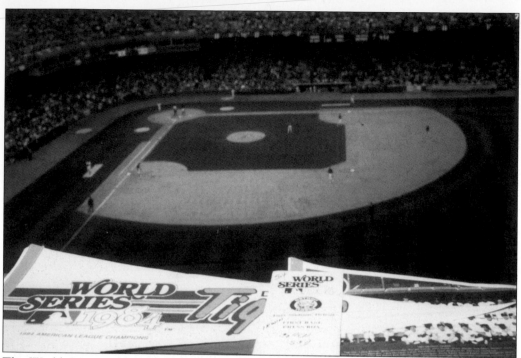

The World Series against the San Diego Padres only took five games and ended on Sunday, October 14 at Tiger Stadium.

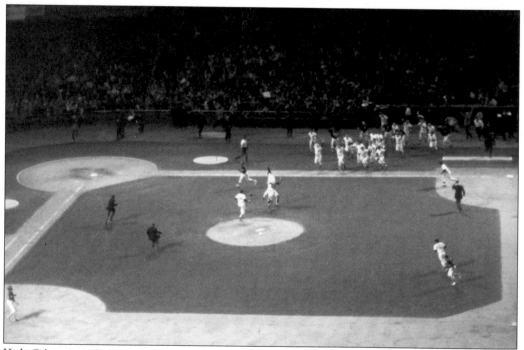

Kirk Gibson's eighth inning home run into the upper deck in right field electrified the 51,901 paying fans and gave the Tigers an 8-4 lead, which stood for the final score and gave way to the celebration that followed. (Photos by author.)

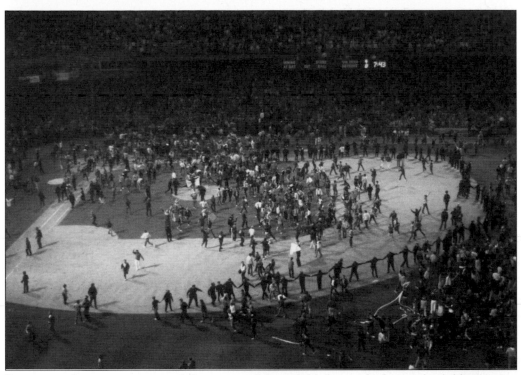

Despite a police presence around the center of the infield, fans rushed onto the field, scooping up dirt and grass as souvenirs.

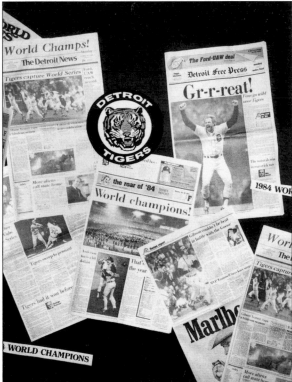

A newspaper display of the happenings of the final game and celebration that followed was posted on a wall in the Tigers' offices. (Photos by author.)

Manager Sparky Anderson had more autograph requests and a new World Series ring.

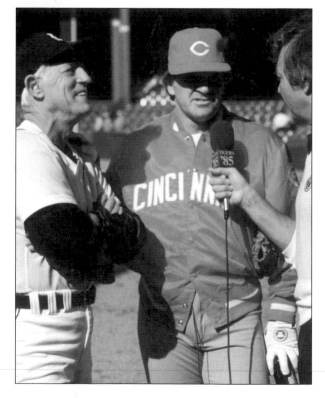

The Tigers and the Cincinnati Reds met in an exhibition game at Tiger Stadium in 1985 to benefit sandlot baseball in Detroit. Reds manager Pete Rose had played under Sparky Anderson in Cincinnati. (Photos by author.)

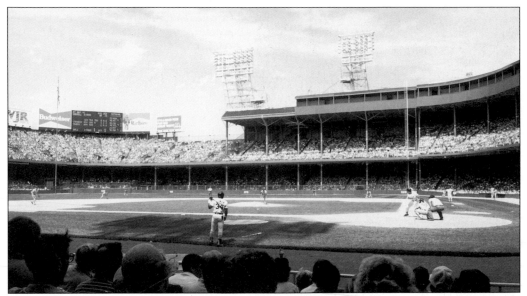

The Tigers slipped to third in 1985, 15 games out. Attendance dropped over 418,000 to 2,286,609, still one of the highest among all teams.

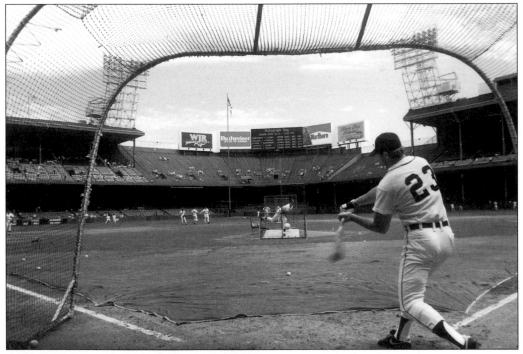

Early arrivals in the upper deck in right field liked to watch Kirk Gibson take batting practice and hoped for a chance to catch a souvenir. (Photos by author.)

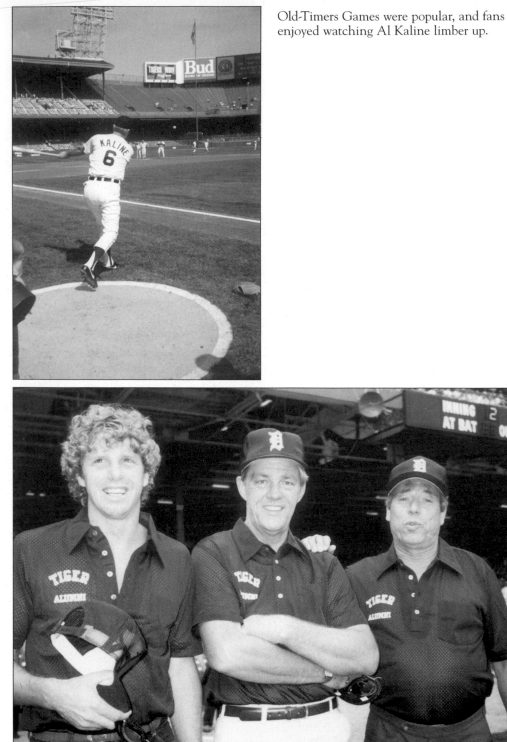

Old-Timers Games were popular, and fans enjoyed watching Al Kaline limber up.

Former players making up the Tiger alumni team look forward to suiting up. Pictured from left to right are Mark Fidrych, pitcher Billy Hoeft, and catcher Joe Ginsberg. (Photos by author.)

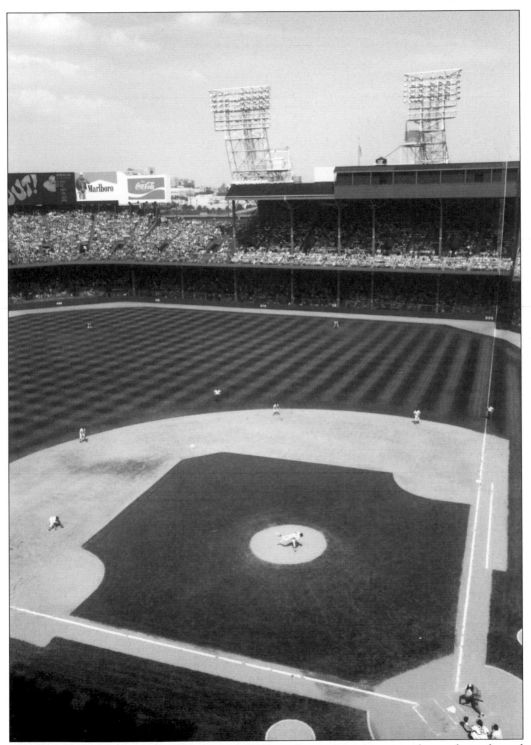

The Tigers won 87 games in 1986, three more than the previous season, and attendance lagged to 1,899,437. (Photo by author.)

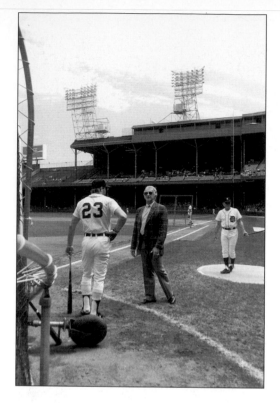

Milwaukee Brewers broadcaster Bob Uecker readies for an interview with Kirk Gibson in 1987.

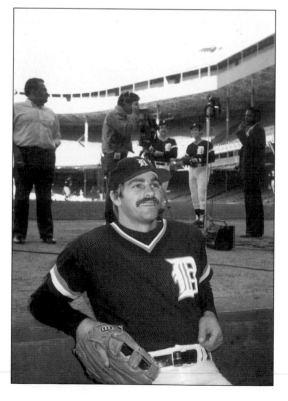

The media often sought out Gibson as speculation surrounded his pending free agency. (Photos by author.)

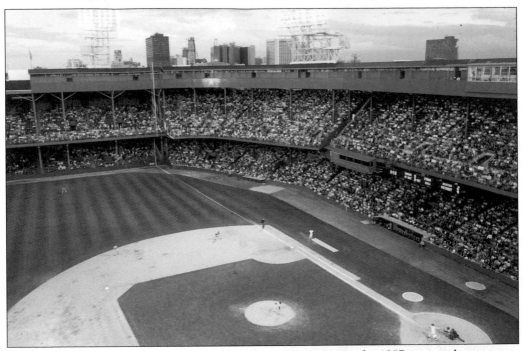

Fan interest returned as the Tigers stayed in the pennant race in the 1987 season, drawing over two million fans.

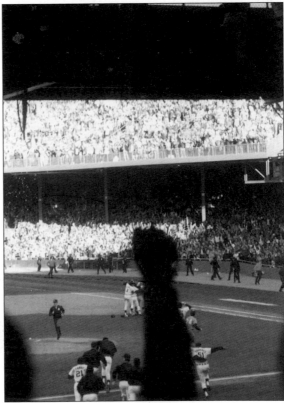

A fan raises his fist in triumph as the Tigers finish the season with a sweep of the Toronto Blue Jays, giving Detroit the American League Eastern Division pennant. Tigers' players rush out of the dugout to celebrate Frank Tanana's 1-0 pitching gem. (Photos by author.)

Some members of the press covering the playoffs between the Tigers and the Minnesota Twins had to peer around the right field foul pole.

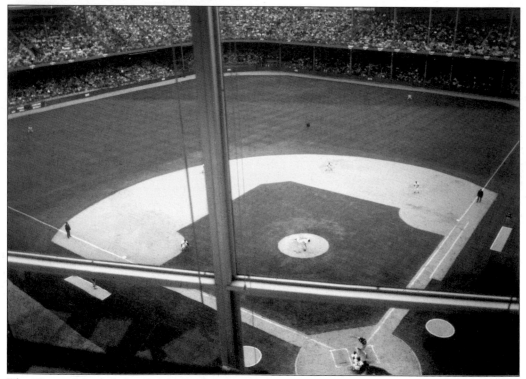

The Twins defeated the Tigers in the playoff, four games to one, ending the 1987 season for Detroit. (Photos by author.)

Kirk Gibson opted for the bigger dollars of free agency and signed with the Los Angeles Dodgers. He became the National League's Most Valuable Player, helping his new club win the 1988 World Series. The Tigers, meanwhile, lost ten more games than in 1987, ending in second place but again drawing over 2 million fans.

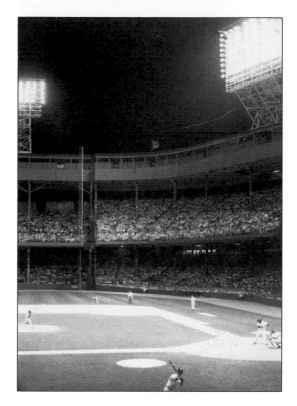

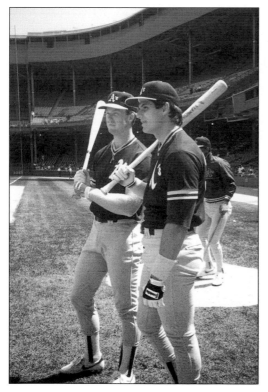

In 1989 Oakland sluggers Mark McGwire (left) and Jose Canseco placed a friendly bet about how many balls they could hit over the left field roof in batting practice. (Photos by author.)

Canseco won the bet as he hit one ball on the roof and one over.

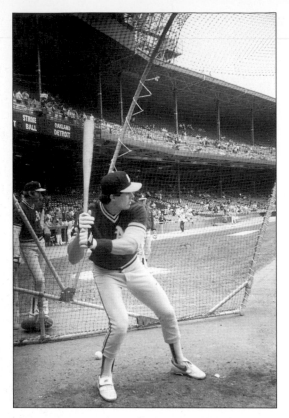

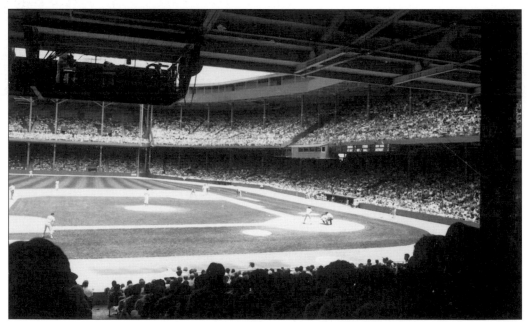

The 1989 Tigers sagged to seventh and lost 103 games while attendance plummeted over a half million. (Photos by author.)

Tigers' officials made public their wish for a new ballpark and their lack of interest in refurbishing Tiger Stadium (lower right). Because the city and state would pitch in with funds, downtown sites near freeways were considered. (Photo by author.)

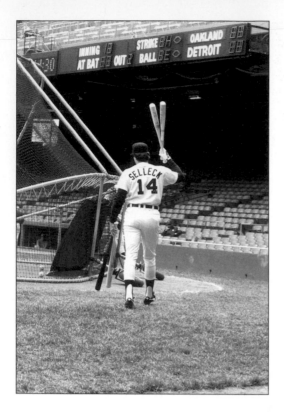

Amidst great secrecy and before the gates opened to the public, Detroit-raised actor Tom Selleck worked out at Tiger Stadium to prepare for the starring role in the movie, *Mr. Baseball.*

Selleck impressed Tigers players as he hit a batting practice home run into the lower right field stands and looked convincing on the field as he caught ground balls and throws to first base. (Photos by author.)

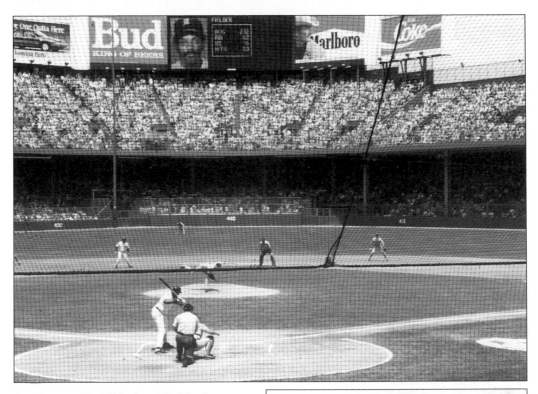

On August 25, 1990, Cecil Fielder became the first Tiger player to hit a home run over the left field roof. The big first baseman led the league with 51 homers, but the Tigers ended the season in third place, nine games out.

Tiger Stadium became the first sports facility placed on the National Trust for Historic Preservation's list of most important endangered historic places. With the ensuing publicity, more fans stopped to read the historic plaque that adorned the exterior on Trumbull near the office entrance. (Photos by author.)

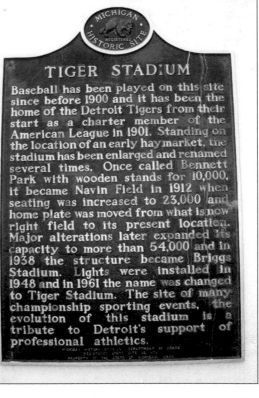

MICHIGAN
REGISTERED
HISTORIC SITE

TIGER STADIUM

Baseball has been played on this site since before 1900 and it has been the home of the Detroit Tigers from their start as a charter member of the American League in 1901. Standing on the location of an early haymarket, the stadium has been enlarged and renamed several times. Once called Bennett Park with wooden stands for 10,000, it became Navin Field in 1912 when seating was increased to 23,000 and home plate was moved from what is now right field to its present location. Major alterations later expanded its capacity to more than 54,000 and in 1938 the structure became Briggs Stadium. Lights were installed in 1948 and in 1961 the name was changed to Tiger Stadium. The site of many championship sporting events, the evolution of this stadium is a tribute to Detroit's support of professional athletics.

MICHIGAN HISTORICAL DIVISION, DEPARTMENT OF STATE
REGISTERED STATE SITE NO. 490
PROPERTY OF THE STATE OF MICHIGAN 1980

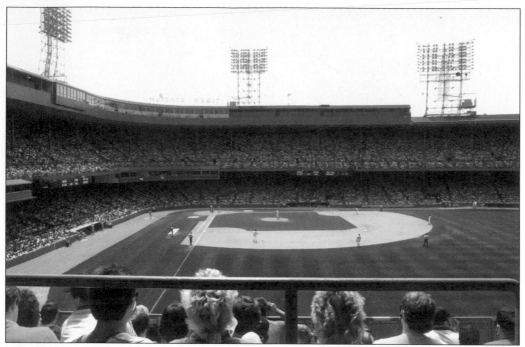

Fans in the box seats in the upper right field seats often caught home run balls. Tigers' catcher Mickey Tettleton didn't give the fans in the stands a chance as he hit two home runs over the roof in less than a week in June 1991.

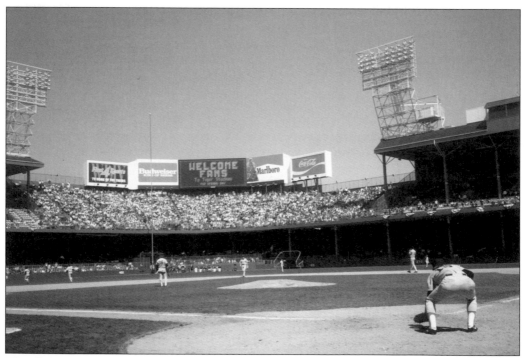

The Tigers improved in 1991, winning 84 games and tying for second place. An increase of almost 150,000 fans attending games brought the final total to 1,641,661. (Photos by author.)

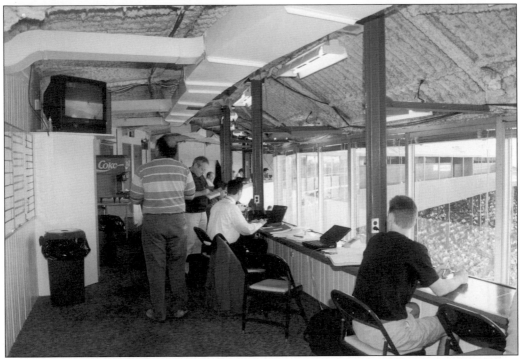

Media people in the press box exchanged opinions and notes when Tom Monaghan sold the team to rival Little Caesars Pizza founder and owner Mike Ilitch for $85 million in August 1992.

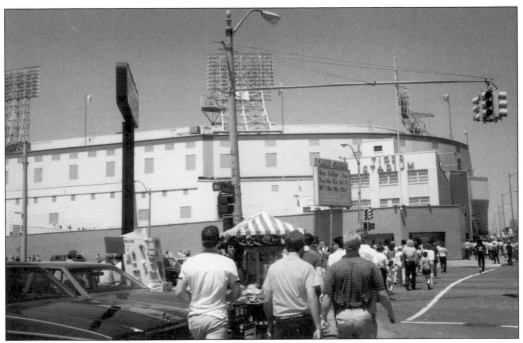

Fans heading to Tiger Stadium offices found several employees terminated by the new pizza regime. Many of them had worked for the Tigers for several decades under different ownerships. Sparky Anderson continued to manage the club, which finished sixth. (Photos by author.)

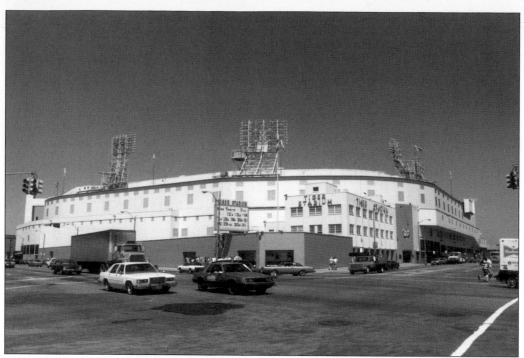

The familiar wall containing the employees' and players' parking area, which ran along Michigan Avenue and north up Trumbull to the Tigers' offices, was demolished to make way for a food court, a souvenir shop, and a snazzier advance ticket office.

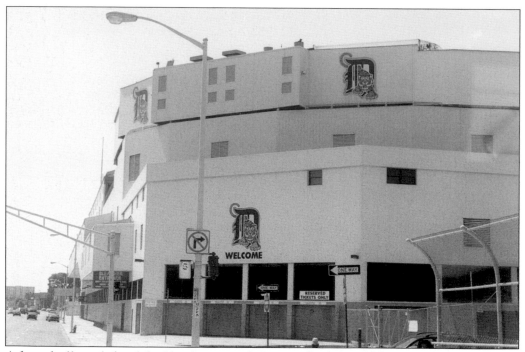

A fenced-off area behind the bleachers provided new parking for employees and players. (Photos by author.)

Fans loved to roam around and through the new plaza.

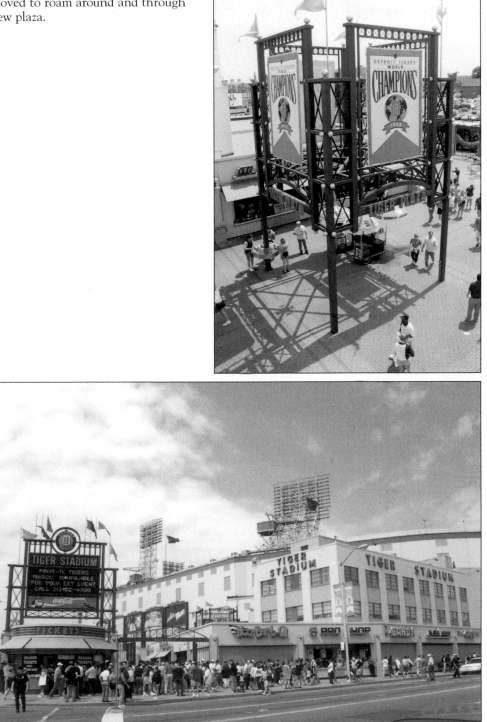

The new Tiger Plaza met with high marks from media and fans. Employees, though, had a much farther walk from the new parking area to Tiger Stadium's offices. (Photo by author.)

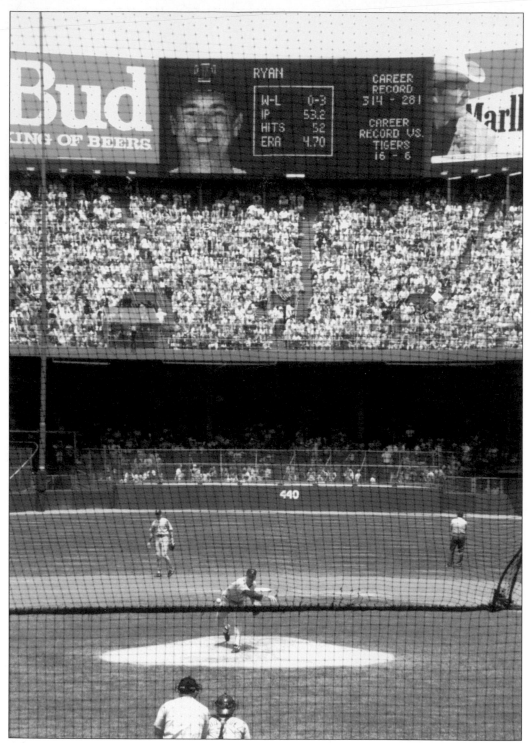

A large crowd came to see Nolan Ryan's last start against the Tigers in 1993. There was renewed interest as the Tigers tied for third place and drew 1,971,421 fans. (Photo by author.)

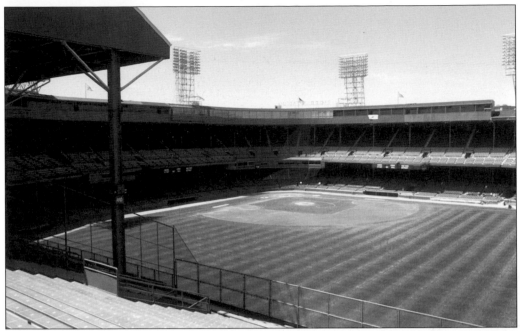

In the strike-shortened 1994 season, the club finished fifth. The strike left a bitter taste with many fans as attendance dropped to less than 1,181,000 in 1995 while watching a fourth place team finish 26 games out of first.

Sparky Anderson, manager since 1979, retired and was replaced by Buddy Bell for the 1996 season. While there was a slight dip in attendance, the team dropped a franchise record 109 games. (Photos by author.)

In 1996 Alan Trammell joined Ty Cobb and Al Kaline as the third player to play 20 seasons for the Tigers. Trammell, popular with teammates, employees, and the media, retired and became the Tigers' assistant to baseball operations. Fans and media loved to chat with Trammell, as it was easy as talking to an adult "Opie" on Aunt Bee's front porch in Mayberry. (Courtesy B&W Photos.)

On April 21, 1997, Oakland's Mark McGwire became the fourth and last player to hit a home run over Tiger Stadium's left field roof. (Photo by author.)

After a third place finish in the 1997 season, ground was ceremoniously broken for what would become Comerica Park.

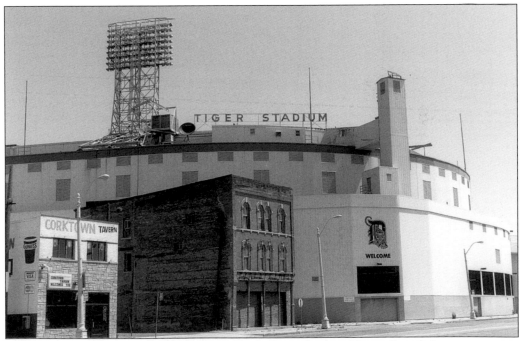

It was another losing season in 1998. Buddy Bell was fired and Larry Parrish became interim manager. Later Parrish was named manager for Tiger Stadium's upcoming last season in 1999. (Photos by author.)

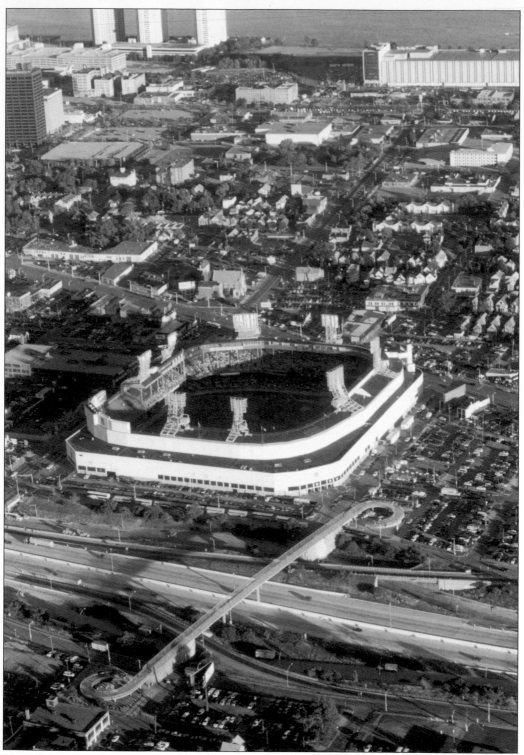

More helicopters flew over Tiger Stadium in its final season. (Courtesy pilot Michael Schupp, photographer Susan Tausch.)

The Tigers were losing more often than winning, but ticket sales were brisk as fans wanted to soak in as much as they could of the old ballpark in its last season.

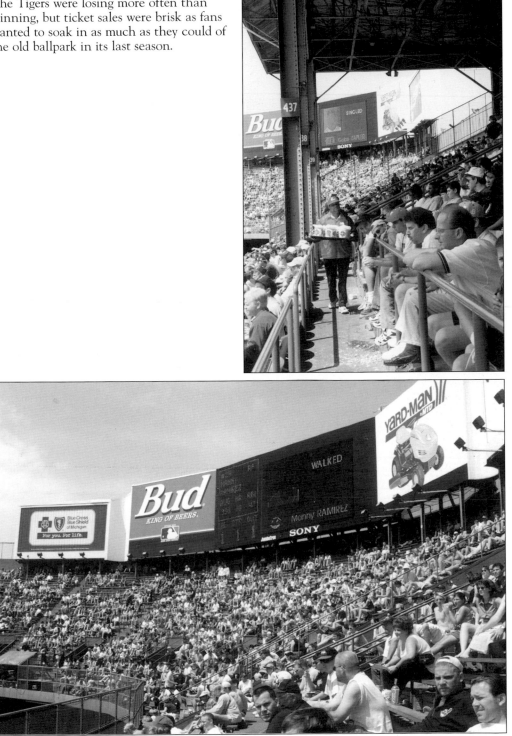

Tiger Stadium was the only major league ballpark with upper deck bleachers wrapping around center field. More fans wanted to experience the view as often as possible. (Photo by author.)

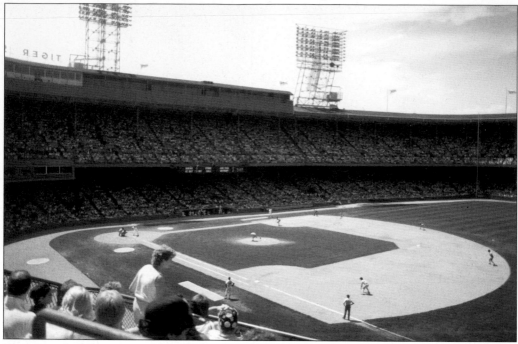

The upper deck box seats along the first base line were the closest to the field of any ballpark.

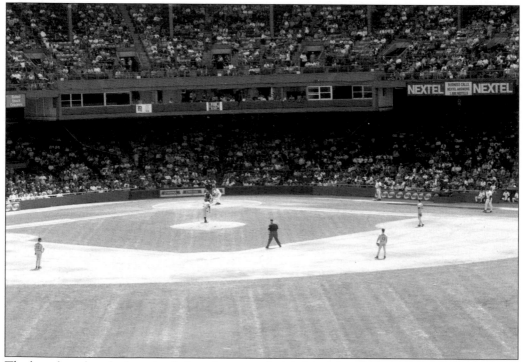

The broadcast booths hanging below the upper deck behind the plate were the closest to home plate of any major league ballpark. (Photos by author.)

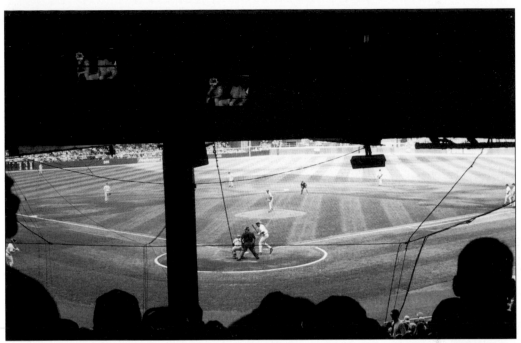

From the top row of the lower deck behind the plate, the back of the low hanging broadcast booths obstructed views of fly balls. (Courtesy Jim Grey.)

Photographers and television technicians enjoyed the closeness to the action provided by the hanging booths in the infield. (Photo by author.)

Players sitting in the dugout also had obstructed views. Another complaint was that the ceiling of the dugout was too low. In 1912 when it was built, players were smaller.

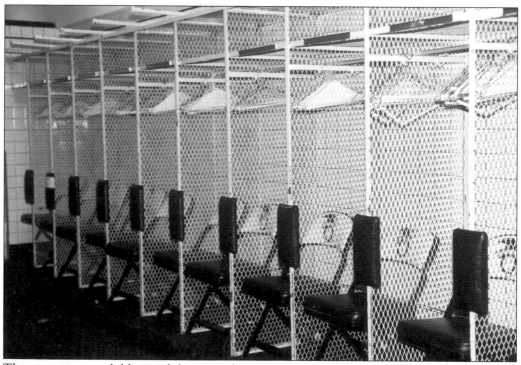

The visiting team clubhouse didn't give players much room to roam around. (Photos courtesy Jim Grey.)

Fans sitting in the lower left field stands between the post and the foul pole had a partial view of the action.

Tiger Stadium led the league in girders and posts. This view overlooks the right field foul line. (Photos by author.)

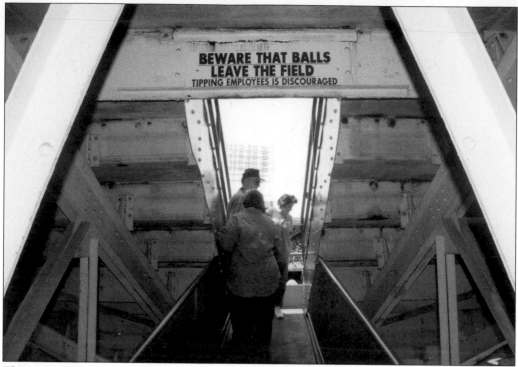

The upper deck ramps and narrow exits were hard to negotiate.

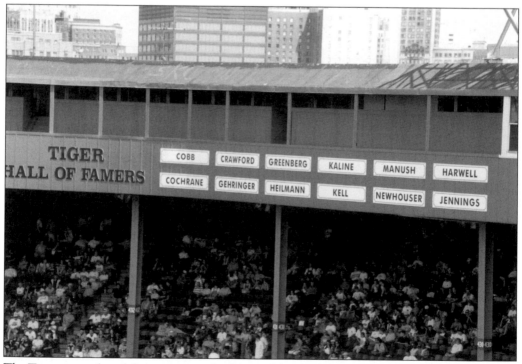

The Tigers remembered their greats on the facing of the third deck near the right field corner. Only Charlie Gehringer and Al Kaline spent their entire careers with the Tigers. (Photos by author.)

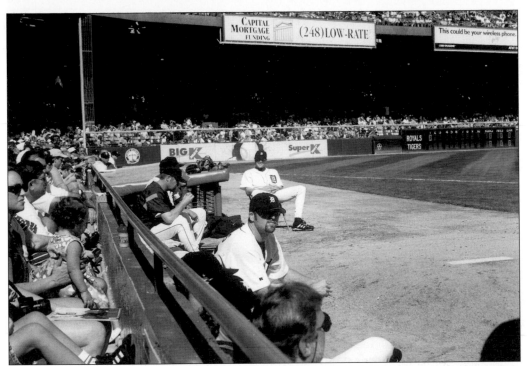

Fans interacted with residents of the Tigers' bullpen along the left field line. (Courtesy Jim Grey.)

The old bullpen behind center field dividing the grandstands and bleachers was being used as a storage area for the batting cage and grounds keeping equipment. (Photo by author.)

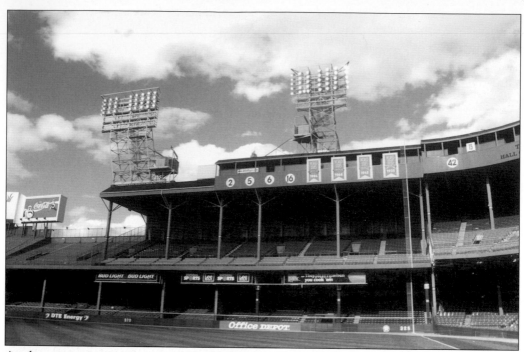

As the remaining games wore down, fans were allowed to walk on the field after games on designated dates.

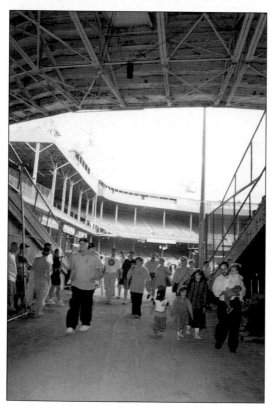

Fans circled the warning track and exited through the old bullpen. (Photos by author.)

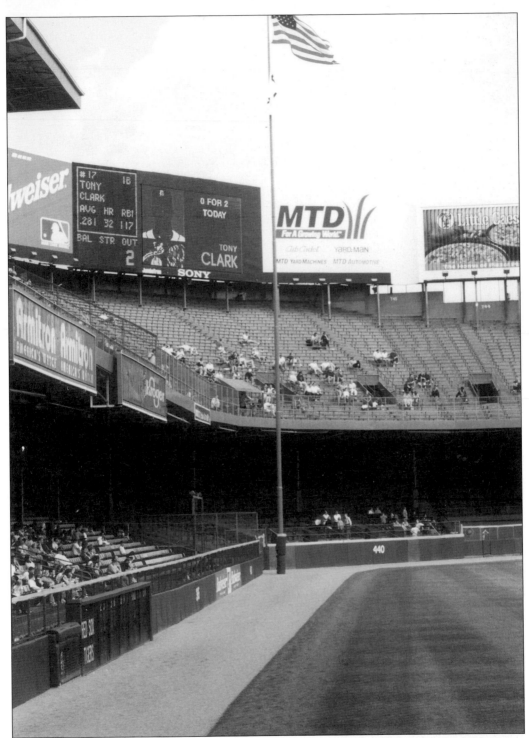

The 125-foot flagpole was the tallest in the major leagues and the only one in the field of play. A ball hitting the flag pole above the horizontal stripe was a home run. (Photo by author.)

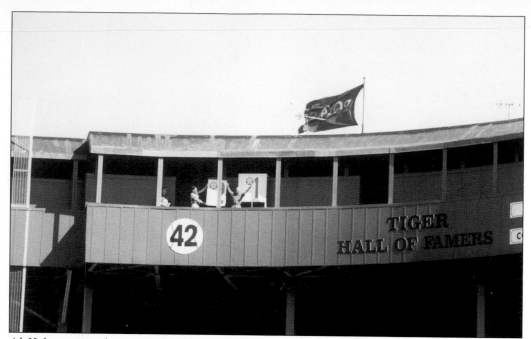

Al Kaline raises his arms for all to see after placing the "one game remaining" sign. The circular number 42 represents Jackie Robinson's retired number with the Dodgers. To honor Robinson, who broke baseball's color barrier, all clubs ceased to issue uniform number 42. (Courtesy Jim Grey.)

The old elevator had more trips to make to the top of the shaft as more media came to Detroit. The walk from the elevator through the tunnel-like shaft to the rear of the press box was more populated than previous years. (Photo by author.)

FIVE

Last Day
SEPTEMBER 27, 1999

No one seemed to care about the Tigers' 68-92 record going into the last game. It was all about the ballpark. Fans arrived early in the morning and set up tailgate parties in parking lots. (Photo by author.)

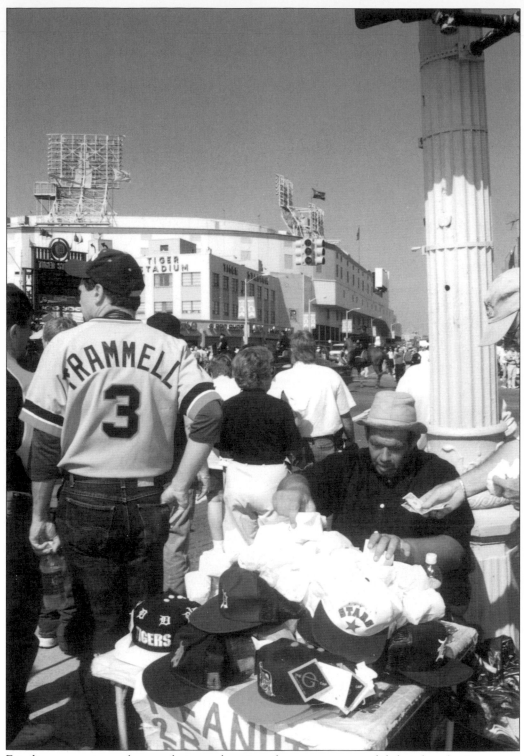

Familiar souvenir vendors, at their usual stations for many seasons, did their best business ever. (Photo by author.)

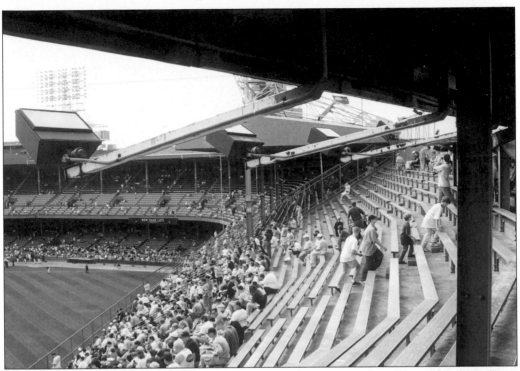

Fans scampered to the top row of the upper bleachers under the scoreboard for a wide angle view.

This is a view from the last row in the right field corner upper deck, two hours before the 6,873rd regular season game to be played at the old ballpark. (Photo by author.)

Lucky fans in the upper deck overhang arrived early, hoping to catch batting practice souvenirs.

The upper deck overhang hovered over the warning track from the foul pole to center field. There were lights under the overhang used to help brighten the warning track. (Photo by author.)

Fans made their thoughts known through homemade signs.

Well before players appeared for batting practice, fans leaned on the left field fence, engrossed in their thoughts and memories. (Photos by author.)

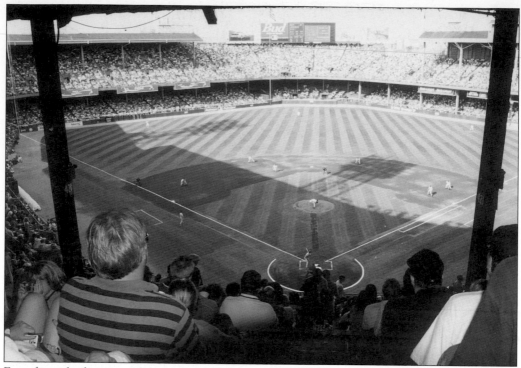

Even from the last row of the upper deck, one could sense the closeness to the field as the final game began in front of 43,356 paying customers in an 84-degree temperature.

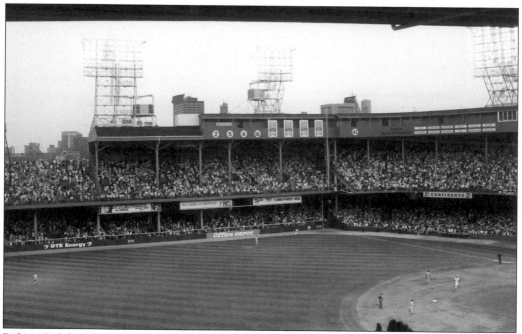

Robert Fick heads toward second base after clubbing a bases-loaded home run off the right field roof in the eighth inning. Fick's blast was the last homer hit in Tiger Stadium, giving the Tigers an 8-2 victory over the Kansas City Royals. (Photos by author.)

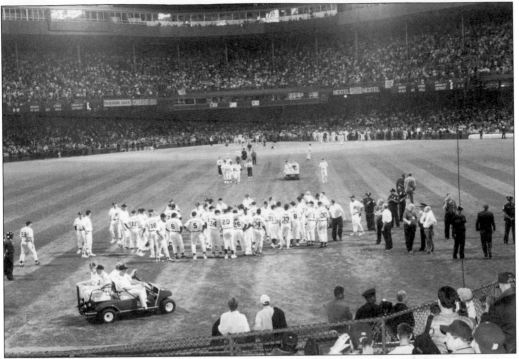

Yesterday's heroes spanning seven decades were introduced in an impressive post-game ceremony. The biggest ovations were reserved for Kirk Gibson and Al Kaline. (Courtesy Jim Grey.)

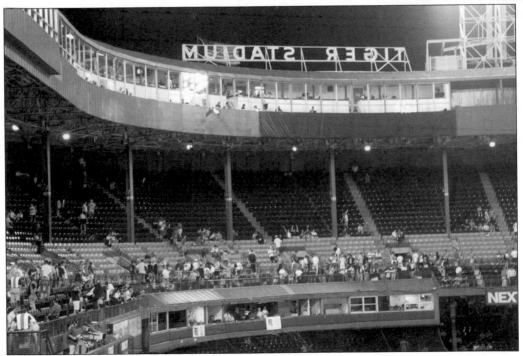

After most light standards were shut off, fans lingered as long as possible for their last long view of Tiger Stadium. (Photo by author.)

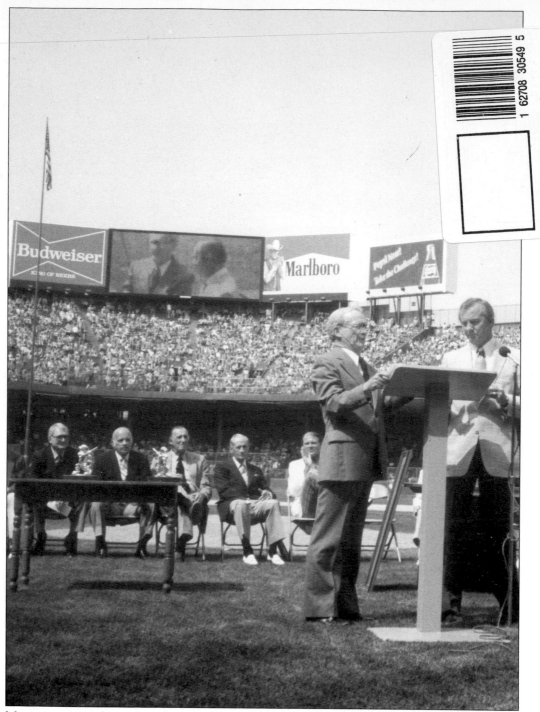

Memories weren't limited to the ballgames. This memorable moment took place between games of a doubleheader in June 1983. Ernie Harwell and Al Kaline presided over the retiring of Charlie Gehringer and Hank Greenberg's uniform numbers. Pictured from left to right are George Kell, Vic Wertz, Greenberg, Gehringer, Bill Freehan, Harwell, and Kaline. (Photo by author.)